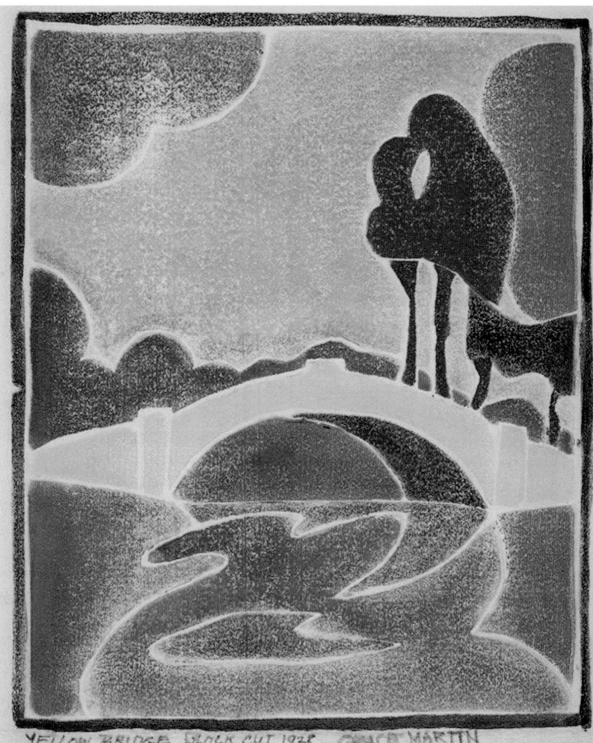

YELLOW BRIDGE BLOCK CUT 1928 GRACE MARTIN

STUDIO WINDOW

THE PRINTS OF GRACE MARTIN TAYLOR

This catalogue was published on the occasion of the exhibition, *Studio Window: The Prints of Grace Martin Taylor*, curated by Robert Bridges, at the Art Museum of West Virginia University, Morgantown, West Virginia, September 16 to December 15, 2016.

Catalogue design by Octavia Steffich.

Cover image: Grace Martin Taylor, *Studio Window*, (detail), ca. 1985-1988 (block cut 1932), see plate 18
Title page: Grace Martin Taylor, *Yellow Bridge*, ca. 1985-1988 (block cut 1928), see plate 12
Foreword: Grace Martin Taylor, *Morgantown Factories*, ca. 1985-1988 (block cut 1928), see plate 10
Preface: Grace Martin Taylor, *Composition No. 2*, ca. 1985-1988 (block cut 1935), see plate 28
Essay: Grace Martin Taylor, *Provincetown House Tops*, ca. 1985-1988 (block cut 1935), see plate 30
Back Cover: Grace Martin Taylor, block for *Morgantown Factories* (block cut 1928)

TABLE OF CONTENTS

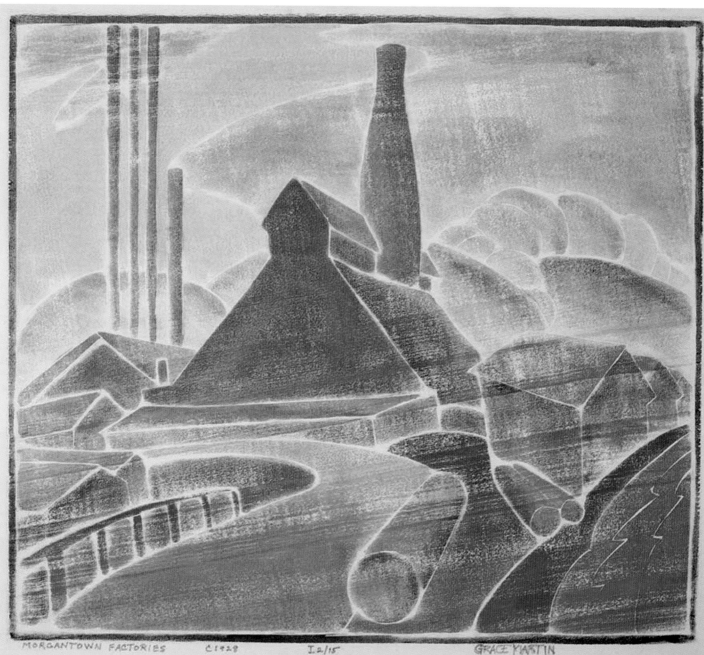

MORGANTOWN FACTORIES C 1929 I 2/15 GRACE MARTIN

FOREWORD

When Grace Martin Taylor died in 1995, she left behind a large body of work created over a long career. Now, thanks to the generosity of her daughter Lucie Mellert, who has donated many of her mother's works to the Art Museum's collection, Taylor's art will be available to a broad public audience.

The Art Museum of West Virginia University (WVU) now holds one of each print that Grace Martin Taylor is known to have made, along with many of the wood and linoleum blocks used to produce them. The museum's collection is greatly enhanced with this addition to its holdings.

It seems especially fitting to have this important collection at WVU because Grace was an alumna and a native West Virginian. Scenes of Morgantown and the area are depicted in many of her prints. Throughout her lifetime, she continued to study with various teachers, including fellow WVU graduate and family member, Blanche Lazzell. Grace Martin Taylor's relationship with Blanche Lazzell as student and teacher, and as a fellow artist, offers new understandings of the ways these two artists influenced one another.

Like Blanche, Grace spent many summers in the stimulating company of the artists in Provincetown, Massachusetts. However, unlike Blanche, Grace Martin Taylor married (twice), had a child, and pursued a career in higher education in West Virginia in addition to her own artistic practice. She was head of the art department and president (1955-56) of the Mason College of Music and Fine Arts (which later became Morris Harvey College, now the University of Charleston). Grace lived a full life of combining work and family during a time that was not especially supportive of a woman following this path.

Found among her papers were cancelled checks written to pay tuition fees for classes with the artist Hans Hofmann, another of Blanche Lazzell's teachers as well. That Grace Martin Taylor saved these items—photographs, notes, and sketchbooks—indicates the importance she placed on her studies and artistic career. This valuable record helps scholars trace those who influenced her growth and development as an artist.

Curator Robert Bridges and professor Kristina Olson bring to this project extensive research into the work of American Modernists which informs their insightful study of Grace Martin Taylor's prints. Assistance on the project was provided by the careful work of Stephen Borkowski, Chair, Art Commission, Provincetown, Massachusetts, Charlene Lattea and Amy Metz Swan.

This catalogue is a publication of the Art Museum of West Virginia University. It is made possible in part through the support of the Myers Foundations to the School of Art and Design, College of Creative Arts.

We are most grateful to Lucie Mellert for her gift that allows the legacy of Grace Martin Taylor's art to be shared with new generations of WVU students, faculty, researchers, and visitors to campus.

Joyce Ice, Ph.D.
Director
Art Museum of West Virginia University

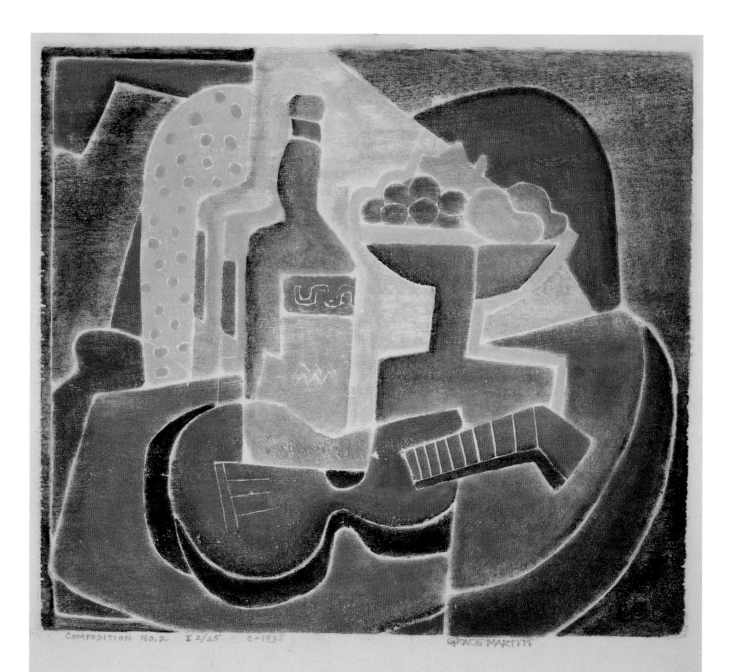

COMPOSITION NO.2 I 2/25 C-1935 GRACE MARTIN

PREFACE

In 1925, the artist Blanche Lazzell (1878-1956) had just returned home to Morgantown, West Virginia, from Paris and study with the artist she called her most significant teacher, Albert Gleizes (1881-1953). Lazzell was at the height of her creative output. She had spent the past year merging her study of Cubism with her interest in American landscape and still life painting. Her artistic production included many of her best color woodblock prints that would define her as an American original. A young artist and distant cousin of Lazzell's, Grace Martin Taylor (1903-1995), had herself recently returned from studying at the Pennsylvania Academy of Fine Arts with modernist Arthur B. Carles (1882-1952).[1] Carles was influenced by the paintings of both Paul Cézanne and Henri Matisse and emphasized the use of expressive color. Most likely because of Lazzell's reputation as a professional artist, Taylor began lessons with her. Although the exact nature of the lessons is unknown, Taylor soon began producing Provincetown white-line prints.

Taylor would not only master the method she learned from Lazzell, but the older artist would continue to mentor the younger Taylor for the next 30 years. Lazzell encouraged her to exhibit at the most prestigious exhibitions and study with the best teachers. Today, they are viewed as the most significant West Virginia artists of the twentieth century and both are recognized nationally as important American modernists. Whereas Lazzell spent most of her professional career in Provincetown, Massachusetts, Grace Martin Taylor dedicated her life to teaching art in her home state and has been credited with perpetuating modern art and abstraction in West Virginia. She brought modern ideas and training back to the state and passed them on to the next generation of artists.

The white-line color woodblock print, or Provincetown print, was an American printmaking innovation developed around 1914-15 by a group of artists working in that town on the tip of Cape Cod. The method revolutionized the artist-made, color woodblock print. It eliminated the tedious process of cutting multiple blocks, one for each color, which was the practice with all Japanese and color woodcut print processes at the time. In the white-line print, artists generally worked up the composition through multiple sketches before transferring the final drawing to the wood plank and then cutting the complete design into a single block (see figure 3). The whole of the composition can be viewed by the artist as it develops. The artist cuts a v-groove in the block to delineate each section of the composition and to separate the colors. Registration is created by pinning the top edge of the paper to the top edge of the woodblock, which allows the artist to lift and paint sections multiple times. The method permitted artists to use layers of transparent color to build luminosity, putting the emphasis on composition and color development rather than on carving techniques. The process was intuitive and more akin to the development of a painting than traditional prints (see figure 2), allowing for working in sections and altering color as the print progressed. Both Lazzell and Taylor were able to use this method to build compositions based on Cubist structure as they developed their colors to emphasize various compositional elements. White-line printers developed a richness of color, compared to other woodblock methods, due to the painterly process and the registration that allowed for layers of color to be built up.

In a 1932 letter to Taylor, Lazzell emphasized the uniqueness of each white-line print and likened them to watercolor paintings rather than traditional prints.[2] In fact, technically speaking, white-line prints are monoprints because they are created one at a time. The artists changed colors from print to print so no two prints are

Fig. 1 Photo: Grace Martin Taylor and Blanche Lazzell, Provincetown, Massachusetts, ca. 1955

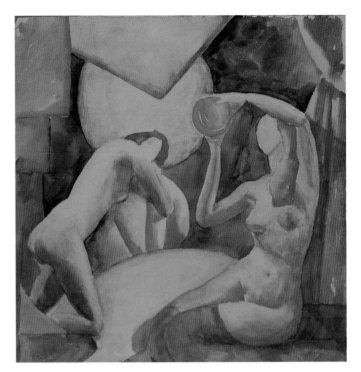

Fig. 2 Grace Martin Taylor, untitled study for *Star Gazing*, ca. 1928, watercolor on paper

alike. The two artists kept each block in the studio and produced a print when it was needed for a sale or if selected for an exhibition. In Blanche Lazzell's "Record of Wood Block Prints" book, the artist kept track of the date and location the block was cut and carefully noted the date each print was printed. Rarely did she print more than one at a time.

In the early 1980s, there was renewed interest in the white-line print. Janet Altaic Flint, Curator of Graphic Arts at the Smithsonian American Art Museum, organized the landmark exhibition *Provincetown Printers: A Woodcut Tradition* in 1983, an impressive survey of the medium that included Taylor's work.[3] Taylor was eighty at the time, but with this revived interest in her prints and with very few on hand, the artist returned to her precious original blocks to produce prints again between 1985 and 1988. Originally the artist's intention was to create a few prints, not to work on all of the blocks, but she kept painting and printing until she had made a complete set. Taylor worked on the prints with the assistance of her daughter, Lucie Mellert, and continued the process over a three-year period each time Mellert visited her mother

in Charleston, West Virginia, from Florida.[4] Taylor selected the paper to use by choosing from paper samples obtained by Mellert. "I would come up from Florida and be with her five-six months at a time and sometimes it would be a whole day or every other day printing…. If she didn't like a color, she made me tear it up. It was a long process."[5] At a late stage in Taylor's career she was active again both making and exhibiting art. "What gets me about mother, she had Alzheimer's, but when she got up to speak before a group she was 25 again…she was that way with her art when we were doing the prints. She knew exactly what color I had to clean off the boards and she would go with me to the kitchen. I had to do everything her way."[6] Over the course of three years, Taylor printed from each block—some of which had not been touched for over fifty years.

Since the Smithsonian's *Provincetown Printers* exhibition, there have been several compelling museum exhibits that featured artists who worked in this medium. First and foremost was the Museum of Fine Arts, Boston, with *From Paris to Provincetown: Blanche Lazzell and the Color Woodcut*, in 2002.[7] This exhibition featured many of

Lazzell's prints, preliminary drawings, and the blocks themselves along with an assortment of woodcuts from her contemporaries. In more recent years, the Cleveland Museum of Art organized the exhibition, *Midwest Modern: The Color Woodcuts of Mabel Hewitt*, and at the Columbus Museum of Art there was *Edna Boies Hopkins: Strong in Character, Colorful in Expression*. These exhibitions captured in depth the strength and importance of the white-line print. This exhibition by the Art Museum of West Virginia University, *Studio Window: The Prints of Grace Martin Taylor*, offers the first time a complete set of Taylor's white-line prints have been exhibited. This is a rare opportunity to view more than 50 of the artist's graphic works. The 34 white-line color woodblock prints, a dozen of her black-and-white linoleum prints and several of the wood blocks themselves, allow for an extensive overview of the work of one of the best Provincetown white-line printmakers.

Robert Bridges
Curator
Art Museum of West Virginia University

ENDNOTES

[1] The artist was born Grace Martin in 1903. She was married to Wilber Frame 1929-1942, becoming Grace Martin Frame. She was married to William Taylor 1951-1961 and remained known as Grace Martin Taylor until her death in 1995. The artist marked the prints in this exhibition that she made during 1985-1988 (when she was between 82 and 85 years old) with her birth name, "GRACE MARTIN."

[2] Letter from Blanche Lazzell, Provincetown, MA, to Grace Martin Frame, Charleston, WV, 2 October 1932 in Grace Martin Taylor papers on loan from Lucie Mellert to the Art Museum of West Virginia University.

[3] See the catalogue for the exhibition by Janet Altaic Flint, *Provincetown Printers: A Woodcut Tradition* (Washington, D.C.: Smithsonian Institution Press, 1983).

[4] Lucie Mellert, phone interview by Robert Bridges and Kristina Olson, Point Pleasant, WV, 29 June 2016.

[5] Ibid.

[6] Ibid.

[7] See the catalogue for the exhibition by Barbara Stern Shapiro, *From Paris to Provincetown: Blanche Lazzell and the Color Woodcut* (Boston: Museum of Fine Arts Publications, 2002).

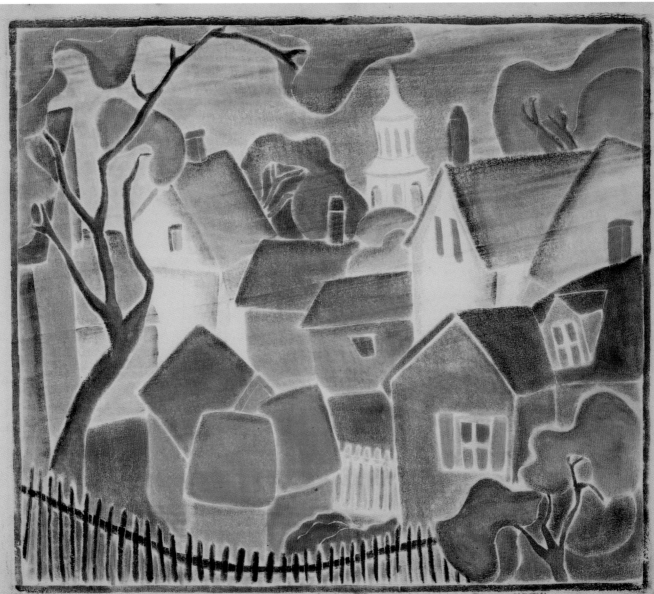

PROVINCETOWN HOUSE TOPS I 3/25 ᴼᶜ 1935 GRACE MARTIN

...CONTROL MUST BEGIN ONLY AFTER CREATION.

- Grace Martin Taylor[1]

The presentation of the complete prints of Grace Martin Taylor (1903-1995) in this exhibition allows for full consideration of this modern American artist's aesthetic, guided by her principle that control in the production of an artwork comes only after creation.[2] That is, intellectual order is brought to bear in the wake of an initial imaginative impulse, not the other way around. It also provides a window through which we can see how this painter, printmaker and educator working in seemingly remote West Virginia contributed to carrying forward the unique process of the Provincetown white-line color woodblock print from its origins in the nineteen-teens to the middle of the twentieth century. Finally, an examination of the specific character of Taylor's prints reveals how she reconciled the angular geometry of the advanced style of Cubism learned from such important American modern artists as her older cousin Blanche Lazzell (1878-1956) and German-born Hans Hofmann (1880-1966) with her own affinity for curved elements and narrative detail related to the work of the French modernist Henri Matisse (1869-1964).[3]

Throughout her long career of teaching and administration (eventually rising to the position of president) at the Mason College of Music and Fine Arts (in Charleston, West Virginia), Taylor considered herself to be a painter.[4] Even as she became involved with the technique of color woodblock printmaking first learned from Lazzell while she was finishing college at West Virginia University in Morgantown (probably about 1925, see Plate 1), the artist followed her older relative's primary identification with painting.[5] The two seemed to be drawn to this particular printmaking technique because of its closer affinities with the singular results of painting rather than with conventional printmaking processes that use a press to produce an edition of identical multiples. In letters sent from her home studio in Massachusetts in 1932, Lazzell counseled Taylor—who was preparing to give a talk about her prints—to emphasize the painterly nature of the Provincetown process:

> There is no book written on the one-block method of the color print as it was only started here about 1914. And I am the only one who has carried it on so continuously and so far. And please do not speak of the color print as a craft. Be sure to make them understand that it is printed one shape at a time and not all at one impression as so many people think. Some people think it is done like a newspaper is printed. Some people ask 'do you color the block each time?' meaning that a number of prints can be made with one coloring of the block. Which is of course an ignorant question....[6]

And in another letter later that month, Lazzell continued:

> Mrs. Chaffee [artist Ada Gilmore Chaffee (1883-1955)] and I are aiming to bring the color print into its own in art. Not as an ordinary print with so many copies. You understand. You might state that you have other prints from the same block but not exact duplicates, as exact duplicates cannot be made in color prints. Be glad you are doing them.[7]

One of Taylor's earliest prints, *Flowers in Window* (block cut 1925, see Plate 1) illustrates the special properties of the white-line technique.[8] Lazzell was directly connected to the origins of the medium. A group of artists, including Ada Gilmore, Edna Bois Hopkins, Ethel Mars, Maud Hunt Squire and B.J.O. (Bror Julius Olsson) Nordfeldt, living in the artists' community of Provincetown, Massachusetts, in 1914-1915 developed a system to create color prints from a single block of wood.[9] The goal was to simplify the centuries-old Japanese color woodblock technique that required a different block to be cut for each form in a print that used a different color. It was a time-consuming endeavor that required shops of professionals to execute each stage of the printmaking process. The Provincetown artists wanted to be able to make their own prints in their modest studios. The real innovation was to use a woodcutting tool to carve a "gutter" between each raised plane of color (see the block for Taylor's print *Bitter Sweet*, block cut 1925, figure 3). Now the artists could transfer their initial sketch to the block themselves, carve the grooves between forms, and then print the image, all from this single surface. To execute the print, a sheet of paper is pinned to the top of the block (see pin holes in Taylor's unframed print *Bitter Sweet*, figure 3), the artist paints a portion of the block (using watercolor applied with a brush), then the sheet is dropped to the block's surface and paint is absorbed by rubbing with a simple tool like a spoon over the reversed side of the paper. While still pinned to the block, the sheet is raised, additional areas are painted, and the process is repeated until all parts of the design are transferred. As Lazzell emphasized in her letters to Taylor, each print is really more like a monoprint (a singular print with no copy) or a painting, due to the individual variations inherent to each print.

Blanche Lazzell probably first instructed Taylor on the technique in private lessons in Morgantown in 1925 while she was staying with her brother. The two artists were cousins on Taylor's mother's side and separated by 25 years. The older Lazzell had already established herself as a modern artist who had just returned from a second trip to Paris to study the progressive style of Cubism with Albert Gleizes (1881-1953). Also a native of West Virginia, Lazzell had learned the white-line technique in Provincetown in 1916 and moved there permanently in 1918. She functioned as a teacher and mentor to her younger relative throughout her life, encouraging her at every turn to pursue her development as a similarly minded modern artist.

The results of Lazzell's instruction are visible in Taylor's early still life prints. The distinct white line that gives the technique its name is visible in the outline of every element in *Flowers in Window*, like the dark vase and the individual petals of the flowers. The painterly quality of the watercolor application comes through in the brushy pale blue of the distorted window behind the vase, or in the variegated brown of the table upon which it sits that indicates a shadow falling to the left, or in the dark modeling of the vertical green element (perhaps the edge of a curtain) to the right that adds a three-dimensional quality to these otherwise flat forms.

A print from three years later, *Lily* (block cut 1928, see Plate 8), demonstrates the artist's sophisticated command of this painterly printmaking process over these three years. The image depicts a large lily on the edge of a garden pool that is balanced on the right of the composition with floating lily pads and a stylized waterfowl. Our eye is guided from the foreground flower over the pool to the curving path, fence, and houses receding in the distance. The complex arrangement of curved and pointed elements is held in balance through color and the wood grain that Taylor has emphasized through carved white lines to indicate ripples on the water's surface. She uses her painter's hand to add modeling, detail, and even the subtle reflection of the bird. The balance, scale-change, interesting perspective, and detail all contribute to the strength of this composition.

The modern aesthetic of these early prints demonstrates

Fig. 3 photo of *Bitter Sweet* print and block (see plate 14)

Fig.4 Blanche Lazzell, *Painting No. 1*, 1925, oil on canvas, 36 x 28 in.

Fig. 5 Blanche Lazzell, *The Monongahela*, 1919, woodblock print, 12 x 11 ½ in.

Taylor's embrace of Cubism. Variations of this radically abstract style were developed by artists (such as Pablo Picasso, Georges Braque, Fernand Léger, and Gleizes) living in Paris in the early years of the twentieth century. Gleizes's version of Synthetic Cubism relied on centrally focused compositions of flat planes in an unmodulated color or abstract pattern animated through overlapping and rotation. Lazzell had absorbed his lessons while in Paris in 1923-1925 and produced a series of non-objective paintings in this vein (such as *Painting No. 1*, 1925, see figure 4).[10] Undoubtedly, Lazzell shared this new knowledge with Taylor late in 1925 during their printmaking lessons in Morgantown. Taylor's modification of this Cubist aesthetic is visible in the flattened, angular planes in the background of her early prints like *Pussy Willow* (see Plate 4) that hold the still life objects to the flat surface of the block and counter traditional one-point spatial recession.

Along with these Cubist tendencies encouraged by Lazzell, we can also see impulses toward her own visual vocabulary in some of Taylor's early prints. *Yellow Bridge* (block cut 1928, see Plate 12) has none of the angular geometry of Cubism. Instead, the artist relies on a system of curves and counter curves to produce this charming image of a stone bridge rendered in yellow crossing a river. The rounded arch of the structure is echoed in the reflections in the water below and in the curvy forms of the trees to one side and at the horizon line in the distance. The pronounced white lines of the

printing process emphasize these curves and gently encourage the eye to move around this small print. It is possible that the subject and treatment was suggested by Lazzell's similarly curvilinear print depicting the bridge in Morgantown, *The Monongahela* (1919, see figure 5), that was made before her studies with Gleizes.

Taylor's reliance on sinuous forms is visible in other early prints focused on scenes in and around her college town. Her version of *The Monongahela River* (also exhibited as *The Monongahela*, block cut 1925, see Plate 3) is a good example. The view shows a row of houses in the foreground in front of a glass factory on the edge of the river in the middle distance. Taylor emphasizes the curve and counter-curve of the river's bends as it flows north through the rounded West Virginia hills into the distance at the center of the print. Typical of Taylor, she adds human, narrative detail in this otherwise unpopulated view with her inclusion of a train steaming along the track on the other side of the river and tiny farmhouses that dot the distant landscape. The undulating curves of the two leafless trees in the right foreground again show the artist's love of rounded forms and emphasize the contrast between organic elements and the sharp angles of man-made structures (such as the rooftops, factory, and black water tower) in this small town scene.

The same treatment is given to the bare trees in *Elizabeth Moore Hall* (block cut 1928, see Plate 7). Taylor depicts the red-brick and white, arched portico of this building on the downtown

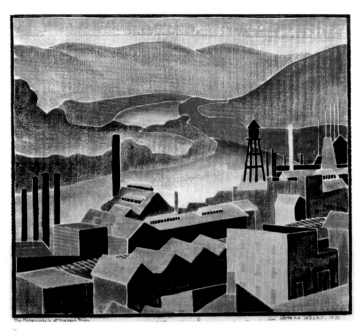

Fig. 6 Blanche Lazzell, *The Monongahela at Morgantown*, 1934, color woodblock print, 12 x 14 in.

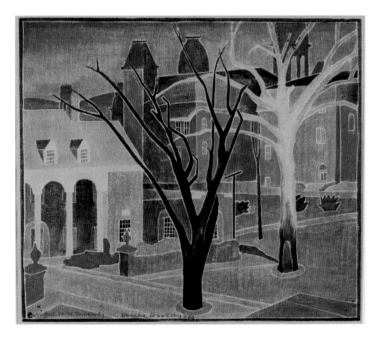

Fig. 7 Blanche Lazzell, *Campus, W. Va. University*, 1935, color woodblock print, 12 x 14 in.

campus of West Virginia University. Again, the sinuous curves in the trunk and branches of the two trees in the foreground and at the extreme left animate this otherwise still view of a distinguished local landmark. Taylor's prints must have impressed her cousin as Lazzell later borrowed these two same subjects for her own work. In fact, Lazzell angled to trade for another print that Taylor had exhibited at the Provincetown Art Association in a postcard from 1935 writing, "I would like to barter with you for your Charleston Cottages [block cut 1932, see Plate 16], the one you showed here once."[11]

During the Great Depression, when Lazzell managed to secure support from the Public Works of Art Project in West Virginia in 1934, she adopted the same subjects as Taylor's earlier prints for two of her three prints depicting scenes of Morgantown.[12] Her view of the glass factory is nearly identical (see figure 6) in terms of perspective, while she shifts her vantage point on Elizabeth Moore Hall to the left of Taylor's to allow for a view toward other campus buildings in Woodburn Circle (see figure 7). Though Lazzell includes gentle hills in the background of both images, her overall approach is much more hard-edged and angular than Taylor's with crisp geometry instead of sweeping curves. Gone too, are Taylor's anecdotal details that bring life to her scenes.

Taylor modified her depiction of the Morgantown glass factory in a later print, *Studio Window*, from 1932, probably created after she settled in Charleston (see Plate 18). This complex print combines a floral still life to the left, with the factory scene viewed through a window to the right.[13] The modern, Cubist-influenced perspective holds the large-scale pitcher/vase in the interior foreground on the same plane as the distant buildings and landscape framed by the window panes. Taylor adeptly contrasts the jumbled array of mixed flowers with the orderly row of houses in the exterior scene. Visual movement is introduced in the swirling pattern of the plate or mat below the pitcher, along with the diagonal lines of the flowers' stems, vessel pattern, and window sill. The artist leaves some of the flowers and buildings intentionally unfinished, emphasizing the modern character of her artwork and its candid revelation of the painterly print technique used in its creation. Given the strength of this composition and its lively coloring, it is not surprising that the print garnered much critical attention. It was included in the *8th Modern Exhibition* at the Provincetown Art Association that same year

(1932) and selected as one of the fifty best color prints in the United States and Canada for an exhibition in California the next year (1933).[14] Additional showings of the print followed at the Corcoran Gallery in Washington, D.C. (1940), the Metropolitan Museum of Art in New York (1942), and Intermont College in Bristol, Virginia (1953).[15]

As early as 1937, Lazzell began writing Taylor to encourage her to visit Provincetown in the summer to study drawing with Hans Hofmann.[16] Hofmann would come to have a significant impact on the development of Taylor's mature art. His role as a teacher of modernism to American artists is legendary.[17] Lazzell wrote Taylor in 1938 stating, "Hofmann is the best teacher I know of in America, as he teaches movement in space."[18] Hofmann had been engaged firsthand with advanced developments in modern art, including Expressionism and Cubism, before he immigrated to the United States in 1930. After initially teaching in California, he established his own school in New York City and taught summer lessons in Provincetown from 1933 to 1958.[19] Taylor participated in classes at his summer school from 1942 to 1957.

Hans Hofmann's appeal as a teacher went beyond the force of his enthusiastic personality and his direct connection to the masters of European modernism. It most importantly involved his ability to provide the techniques and rationale to make a modern picture. His main formal lesson to students was to activate a composition through spatial interplay. He articulated this lesson through his well-known emphasis on the push-and-pull of pictorial space.[20] The goal in his classes was to focus on the mechanics of evoking the third dimension in accord with the two-dimensional nature of the picture surface. All subject matter was reduced to a series of planes that abstractly expressed nature's volumes.

The daily schedule for the Provincetown classes in a barn-like structure on Miller Hill Road followed that of his New York school. In the mornings, students drew from a live model, while the afternoons were devoted to working from still-life arrangements.[21] As did Lazzell, Taylor probably revised dozens of figure drawings (untitled drawing, 1951, see figure 8) in these sessions as Hofmann encouraged her toward greater abstraction and complication of space. Such drawings were not considered finished works, but rather studies in which to come to terms with his modern pictorial principles. The anatomical features of head, body, and limbs in

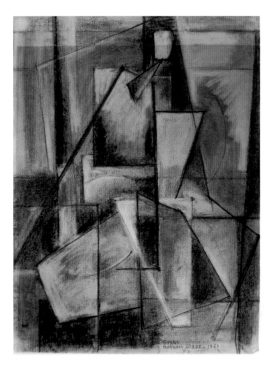

Fig. 8 Grace Martin Taylor, *untitled* [Hofmann class drawing], 1951, charcoal on paper, 25 x 19 in.

the seated model posing for Taylor's drawing, for example, have been radically simplified to basic geometric shapes set in motion by emphasizing diagonal lines. Following Hofmann's instruction, she used shading in charcoal and highlights of the white paper to push some areas back into spatial recession, while others are pulled forward to project. A finished figure painting in watercolor from 1938 (*No. 10 Model*, see figure 9) demonstrates Taylor's confident execution of Hofmann's principles of floating spatial planes and diagonal lines, while bringing in her personal preference for curves (in the exaggerated leg to the left and shoulder and bottom to the right) and detail (in the model's facial features, breasts, and feet).

Hofmann's lingering impact is visible in the paintings made at the height of Taylor's career. The sure-handed, untitled abstract painting from 1940 (see figure 10) uses Hofmann's patchwork-like zones of projecting and receding color, coupled with Taylor's signature curve and counter-curve in the two largest vertical shapes. This movement, along with the distinct black lines and bright orange wedge that functions like an exclamation point at the lower left, animates this delightful composition. It is reminiscent of Hofmann's own simplified organic abstractions from the 1940s,

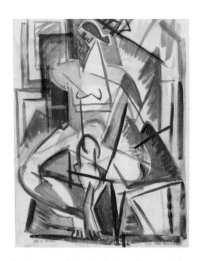

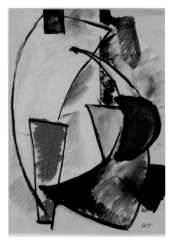

Fig. 9 Grace Martin Taylor, *No. 10 Model*, 1938, watercolor on paper, 19 3/8 x 15 3/8 in.

Fig. 10 Grace Martin Taylor, *untitled*, 1940, oil on paper, 10 1/4 x 14 1/2 in.

dimensionality to this otherwise flat composition.

The print was much admired. It was included in at least a dozen exhibitions at venues such as the Corcoran Gallery in Washington, D.C. (1940), Ohio University, Athens, Ohio (1945), the National Academy of Design in New York, New York (1946 and 1948), Intermont College, Bristol, Virginia (1948), and the Denver Art Museum, Denver, Colorado (1960).[22] While on exhibit in New York in 1948, *Pink Torso* was described by art critic Edward Alden Jewell as, "one of the handsomest contributions in the color print field" in his review for the *New York Times*.[23]

Matisse was a French modernist associated with the style of Fauvism that preceded Cubism in developments in modern art at the beginning of the twentieth century. He pioneered the use of flat, bright color in warm and cool tones to abstract his forms, and such as his *Still Life* (1943, figure 11).

Taylor's paintings of the 1960s and '70s resonate with Hofmann's celebrated late work, where he used thickly applied oil paint in patches of bright color to create brushy rectangles that hover in space. In her *Summer Resort* from 1969 (see figure 12), Taylor created a similar non-objective composition with painterly rectangles of lively, mixed colors that seem to float forward and recede back, while quirky black lines and checkerboard patterns hint at recognizable forms, movement, and a visual narrative.

The special nature of Taylor's aesthetic comes in the way she balanced the geometry of Cubism—which she learned from Lazzell and Hofmann—with her own career-long reliance on curved elements to introduce movement. Returning to Taylor's prints of the 1930s, we can see that this commitment is especially visible in her treatment of the female nude and points to her growing appreciation of the work of Henri Matisse. Though technically a still-life subject, *Torso* (also exhibited as *Pink Torso*, block cut 1932, Plate 19) is centered on the truncated female torso of a carved sculpture that has been set amidst a table top arrangement of dishes and fruit. The geometric, Cubist planes are countered by the curves of the figure that are doubled with the reflection of the back side of the sculpture in a mirror at the right. Taylor's soft pink coloring for the body contrasts with the bright purple and oranges of the fruit while her painterly modeling of the figure's curves brings

Fig. 11 Hans Hofmann, *Still Life*, 1943, watercolor on paper, 24 x 19 in., courtesy of Harvey and Jennifer Peyton, Nitro, West Virginia

had a life-long focus on the female nude as a primary subject (such as in his masterpiece, *Joy of Life*, 1905-06). Taylor seemed to have a long-standing interest in Matisse's work and it is an influence that went beyond Lazzell's and Hofmann's commitment to the formal rigor of Cubism. She must have seen many examples of his work in person at major museums during her travels, studies and especially during her many visits to the Museum of Modern Art (MoMA) in New York.[24]

Taylor's studio records contain items devoted to Matisse that include the catalogue for the *Henri Matisse* exhibition of 1951-52 that originated at MoMA and that Taylor seems to have visited when it traveled to the Cleveland Museum of Art. She also held on to the brochure for the *Henri Matisse Retrospective* on view at the Museum of Fine Arts, Boston, after his death in 1954.[25] Letters and an invoice show that Taylor ordered one of Matisse's *Mimosa* wool rugs (1949-51) initially produced by Alexander Smith and Sons Company and finally acquired from W & J Sloane in 1951. It likely hung on the wall of her McClung Street home in Charleston.

There are telling comments from Taylor regarding her admiration for Matisse in studio notes probably written in late 1949 after a trip to New York in November.[26] Following the travel notation, she makes astute observations regarding the work of several modern masters included in a book by Fiske Kimball and Lionello Venturi (1948) on great paintings in American collections that she must have recently read.[27] Her notes discuss the work of Picasso, John Marin, and Georges Rouault before considering Matisse's work at length. She begins, "To understand Picasso the guiding element is abstract form, to understand Matisse it is abstract color."[28] The book includes a full-page reproduction of Matisse's *The Blue Window* (1913).[29] The painting depicts an interior still life of highly abstracted objects on a table in front of a large window offering a landscape scene beyond. Perspective is radically flattened and the composition unified by the overall cool blue tonality. After quoting Matisse extensively, Taylor makes this remarkable formal analysis of the work (with a number of abbreviated terms):

> In *Blue Window* the objects are represented by patterns, not by plastic forms; at most a reflection of light in the glass vase of flowers suggests its depth. The rep. [representation] of things is purely symbolic, transforming them into

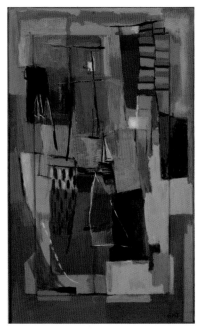

Fig. 12 Grace Martin Taylor, *Summer Resort*, 1969, acrylic on board, 37 ½ x 22 ½ in.

their phantasms. The whole composition emphasizes the surfaces at the expense of the 3rd dimension. There is a hint of space behind the objects, but it is a comp. [composition] of space which is purely symbolic, an indication not a representation. No movement is sug. [suggested] in the various patterns. Because movement is always merely suggestive of actual life, the static appearances of *Blue Window* remain a presentation & not a rep. [representation.] Matisse controls his work but he knows that <u>control</u> <u>must</u> <u>begin</u> <u>only</u> <u>after</u> <u>creation</u> [Taylor's emphasis].[30]

Taylor's perceptive insight into the work of the French modernist in 1949 suggests a sophisticated understanding of her own aesthetic goals going into her artistic prime. Returning to a print from 1930 (*Sails and Gulls*, block cut 1930, Plate 13), we see Taylor's native love for interlocking curves in this scene of sailboats, probably off of Cape Cod, created long before her studies there with Hofmann. Following her stated conviction of the artist exerting control only after an initial creative inspiration, Taylor has brought order to this lively view of a rocky foreground, sailboats, flying

gulls and a rainbow in the middle ground, with a distant view of Provincetown wharf buildings at the right. Typical of the artist, she uses the sharp white lines of the printmaking technique to emphasize curves and counter-curves in this complex arrangement that balances the movement suggested in the sky, gulls, and full sails with the stability of the vertical mast of the foremost boat.

Another Cape Cod scene (*Cape Cod Sand Dunes*, block cut 1935, Plate 27) offers a rare, pure landscape entirely given over to Taylor's roiling curves.[31] The rising dune at the lower right leads our eye into the print, dropping down to a road or path at the left middle ground that directs us toward the view of the ocean and a rising group of gulls at the center horizon line. All anecdotal detail (such as clots of beach grass, bending tree, and flying birds) have been orchestrated to keep the eye gently meandering through this abstracted vista.

In a discussion of modern art from late in her life, Taylor summarized her artistic process, emphasizing her imposition of control only after an initial creative impulse:

> There is no formula for abstract painting. If there were it would have died years ago. Each artist has his own approach. I use a subject only for inspiration. Then I break it down into its simplest elements and develop it from there. There is excitement in planning a movement around a pivot, in, out, and across a picture plane to plot a design which is vibrant with harmonic life. That brings up music. A melody in music can flow up and down the scale. A harmony in a painting flows in and through the picture field by virtue of relationships of color, space, and plane. Making all of these elements behave is similar to conducting a symphony orchestra–trying to have all parts working together and in harmony to express a unified composition.[32]

Finally, the prints of Grace Martin Taylor are strongest when this love of harmony, made manifest through her curved elements, is added to her conceptual grasp of modern pictorial space learned from such Cubist masters as Lazzell and Hofmann. Her most competent prints, such as *Charleston Cottages* (block cut 1932, Plate 16) and *Hollyhock Time* (block cut 1932, Plate 17), use those repeated curves and anecdotal visual details to draw viewers into the composition, keeping them engaged and leaving them with a sense of aesthetic cohesion. The body of prints included in this exhibition speaks to the singular accomplishment of one aspect of this committed artist/educator's extensive career. It testifies to her mastery of the Provincetown white-line woodblock technique and her sophisticated command of the advanced aesthetics of twentieth-century modernism. In a late interview, Grace Martin Taylor summed up her sense of her place in art history and her legacy for the future:

> You said something about a philosophy of art, and I was trying to think of my own. I would say that I have a solemn reverence for all the great masters, the old as well as the new, who have persevered at great cost to achieve that, and make the new discoveries from which we all benefit. Then, we should pass the good things on to the young people who are depending on us to lead them. It is a great objective.[33]

Kristina Olson
School of Art & Design
West Virginia University

Grace Martin Taylor at Lynn Laskin Galleries, Charleston, West Virginia, 1957

ENDNOTES

1 Grace Martin Taylor, untitled studio notes, ca.1949, n.p., in Grace Martin Taylor papers on loan from Lucie Mellert to the Art Museum of West Virginia University.

2 The artist was born Grace Martin in 1903. She was married to Wilber Frame 1929-1942, becoming Grace Martin Frame. She was married to William Taylor 1951-1961 and remained known as Grace Martin Taylor until her death in 1995. The artist marked the prints in this exhibition that she made during 1985-1988 (when she was between 82 and 85 years old) with her birth name, "GRACE MARTIN."

3 Research and writing of this catalogue essay was supported by a Myers Foundations Faculty Distinguished Research Award funded through the Myers Foundations to the School of Art & Design at West Virginia University. The author is grateful for this generous support.

4 Mason College was later known as Morris Harvey College and is now the University of Charleston.

5 Late in life, Taylor stated, "The medium I have always preferred, I believe because I think it's the most challenging, is oil painting." From an interview with former student, John F. Hudkins published in the exhibition brochure *Grace Martin Taylor* (Charleston, WV: West Virginia Department of Culture & History, 1981), n.p.

6 Letter from Blanche Lazzell, Provincetown, MA, to Grace Martin Frame, Charleston, WV, 2 October 1932 in Grace Martin Taylor papers on loan from Lucie Mellert to the Art Museum of West Virginia University.

7 Letter from Blanche Lazzell, Provincetown, MA, to Grace Martin Frame, Charleston, WV, 22 October 1932 in Grace Martin Taylor papers on loan from Lucie Mellert to the Art Museum of West Virginia University.

8 As discussed in Robert Bridges' preface in this catalogue, Taylor's color woodblock prints in this exhibition were all printed during 1985-1988 by the artist with the assistance of her daughter, Lucie Mellert, from her original woodblocks that had been cut and initially printed decades earlier. For the purposes of this essay, which follows Taylor's developments in printmaking chronologically, dates are given as the original year the block was cut.

9 See the chapter on "The Provincetown Print" by David Acton in Robert Bridges, Kristina Olson and Janet Snyder, eds., *Blanche Lazzell: The Life and Work of an American Modernist* (Morgantown, WV: West Virginia University Press, 2004), 169-205.

10 See the chapter, "Studying with Albert Gleizes in 1924," by Peter Brooke in *Blanche Lazzell: The Life and Work of an American Modernist* (see note 9), 207-227.

11 Postcard from Blanche Lazzell, Provincetown, MA, to Grace Martin Frame, Charleston, WV, 15 January 1935 in Grace Martin Taylor papers on loan from Lucie Mellert to the Art Museum of West Virginia University.

12 See the chapter, "The Federal Arts Projects, 1934-39," by Marlene Park in *Blanche Lazzell: The Life and Work of an American Modernist* (see note 9), 229-250.

13 The view may recall the earlier vantage point Taylor had from one of her Morgantown apartments at either 240 Franklin Street (occupied 1925-27) or 162 First Street (occupied 1931). The author is indebted to the research of Charlene Lattea for this information.

14 See exhibition information taken from the Grace Martin Taylor papers on loan from Lucie Mellert to the Art Museum of West Virginia University included on page 43 of this catalogue.

15 Ibid.

16 "What are your plans for the summer? I wish you could or would come here for two months and study with Hofmann. It would be quite an inspiration to you." Letter from Blanche Lazzell, Provincetown, MA, to Grace Martin Frame, Charleston, WV, 1 July 1937 in Grace Martin Taylor papers on loan from Lucie Mellert to the Art Museum of West Virginia University.

17 The list of notable Hofmann students includes: Nell Blaine, Peter Busa, Fritz Bultman, Ray Eames, Helen Frankenthaler, Jane Freilicher, Robert Goodnough, Red Grooms, Carl Holty, Wolf Kahn, Allan Kaprow, Lee Krasner, Marisol, Joan Mitchell, Louise Nevelson, Robert De Niro Sr., Larry Rivers, and Richard

Stankiewicz among many others. See note one in the Irving Sandler essay on the estate of Hans Hofmann website at: www.hanshofmann.org.

[18] Letter from Blanche Lazzell, Provincetown, MA, to Grace Martin Frame, Charleston, WV, 9 June 1938 in Grace Martin Taylor papers on loan from Lucie Mellert to the Art Museum of West Virginia University.

[19] Robert Bridges and Kristina Olson, *Blanche Lazzell: The Hofmann Drawings* (Morgantown, WV: Mesaros Galleries-West Virginia University, 2004), 9.

[20] Ibid., 18.

[21] Cynthia Goodman, "Hans Hofmann as a Teacher," *Arts Magazine* 53 (April 1979): 122-123.

[22] See exhibition information taken from the Grace Martin Taylor papers on loan from Lucie Mellert to the Art Museum of West Virginia University included on page 45 of this catalogue.

[23] "*Pink Torso* which was included in the National Academy of Design exhibition in NYC in 1948 was described by Edward Alden Jewell art critic for the *New York Times* in the 1940s as, 'one of the handsomest contributions in the color print field.'" Grace Martin Taylor, studio notes, 1948, n.p., in Grace Martin Taylor papers on loan from Lucie Mellert to the Art Museum of West Virginia University.

[24] Taylor's notes indicate several train trips to New York from Charleston. In 1945, she participated in a group tour of the Museum of Modern Art and the National Academy of Design in New York, New York with art historian Sheldon Cheney. Grace Martin Taylor, undated studio notes, n.p., in Grace Martin Taylor papers on loan from Lucie Mellert to the Art Museum of West Virginia University.

[25] Grace Martin Taylor, undated studio folder, in Grace Martin Taylor papers on loan from Lucie Mellert to the Art Museum of West Virginia University.

[26] Travel notes list details for a trip to New York from Charleston on 23 November 1949. Grace Martin Taylor papers on loan from Lucie Mellert to the Art Museum of West Virginia University, n.p.

[27] Fiske Kimball and Lionello Venturi, *Great Paintings in America* (New York: Coward-McCann, Inc., 1948).

[28] Grace Martin Taylor, untitled studio notes, ca.1949, n.p., in Grace Martin Taylor papers on loan from Lucie Mellert to the Art Museum of West Virginia University.

[29] Matisse's *The Blue Window* is in the collection of the Museum of Modern Art, New York, New York and was acquired and first exhibited there in 1939. See "The Collection," the Museum of Modern Art, accessed 26 July 2016, http://www.moma.org/collection/works/79350?locale=en.

[30] Grace Martin Taylor, untitled studio notes, ca.1949, n.p., in Grace Martin Taylor papers on loan from Lucie Mellert to the Art Museum of West Virginia University.

[31] The print bears a resemblance to Blanche Lazzell's print *Color Organization* of 1918.

[32] Quoted in John Cuthbert and Gale Simplicio, *Grace Martin Taylor 1903-1995*, exhibition brochure (Morgantown, WV: West Virginia University Libraries, 1996), 8.

[33] From an interview conducted in 1981 with John F. Hudkins (see note 5), n.p.

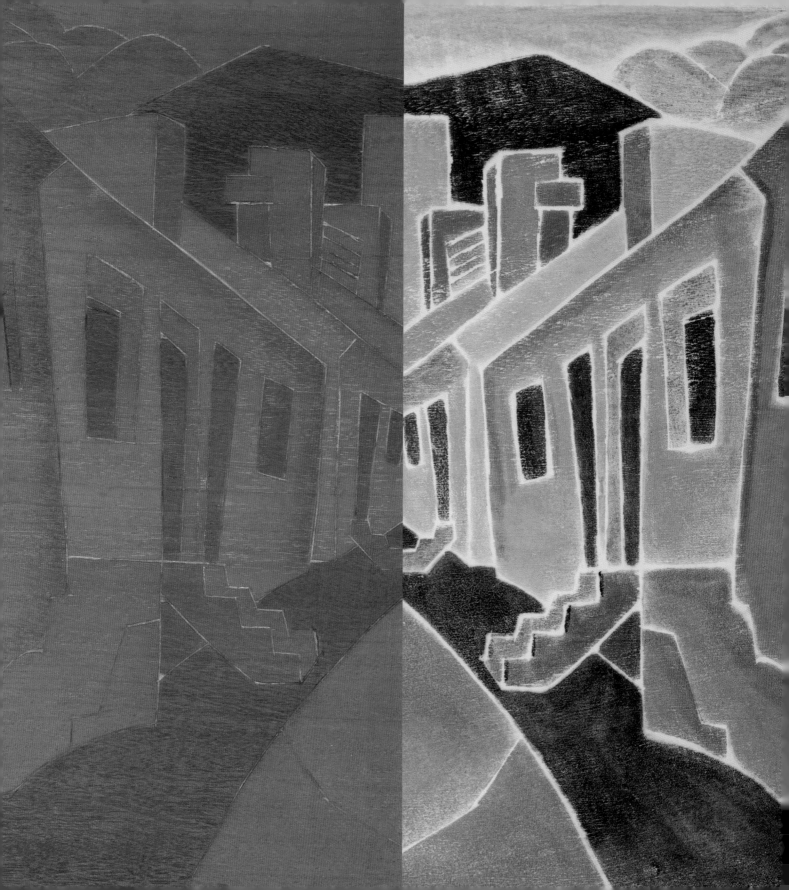

PLATES

Catalogue Raisonné of the Prints of Grace Martin Taylor

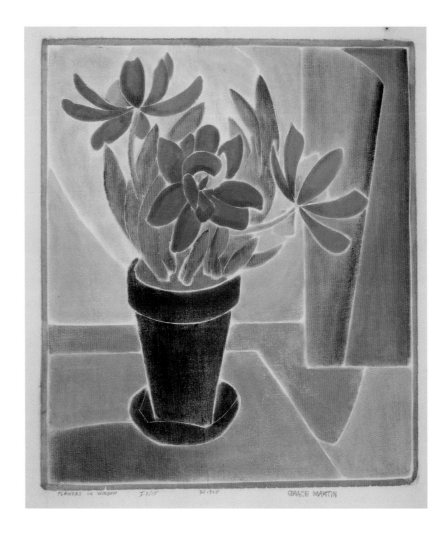

Pl. 1: ***Flowers in Window*** [also known as *Tulips*], ca. 1985-1988 (block cut 1925)
Color woodblock print on paper
Sheet size: 15 ¾ x 15 in. (40 x 38.1 cm.)
Image size: 13 7/8 x 12 in. (35.2 x 30.5 cm.)
2011.3.7
Marked: FLOWERS IN WINDOW I 2/15 BC1925 GRACE MARTIN

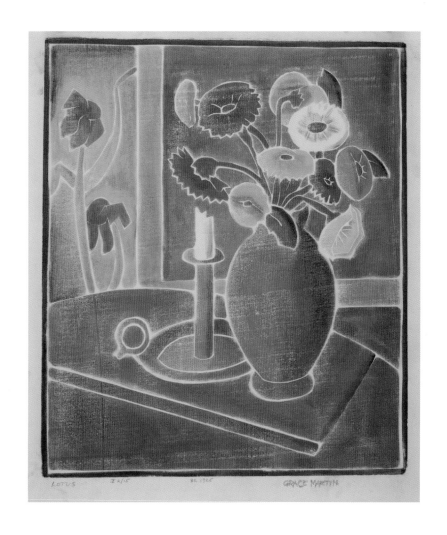

Pl. 2: ***Lotus***, ca. 1985-1988 (block cut 1925)
Color woodblock print on paper
Sheet size: 15 ¾ x 14 7/8 in. (40 x 37.8 cm.)
Image size: 13 ¾ x 12 in. (34.9 x 30.5 cm.)
2011.3.11
Marked: LOTUS I 2/15 BC1925 GRACE MARTIN

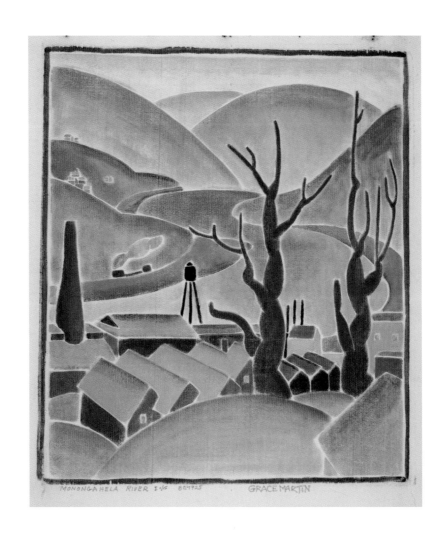

Pl. 3: ***Monongahela River*** [also known as *The Monongahela*], ca. 1985-1988
(block cut 1925)
Color woodblock print on paper
Sheet size: 16 ¼ x 14 ¾ in. (41.3 x 37.5 cm.)
Image size: 13 ¾ x 12 in. (34.9 x 30.5 cm.)
2011.3.14
Marked: MONONGAHELA RIVER I 1/15 BC1925 GRACE MARTIN

EXHIBITIONS:

4th Modern Exhibition, Provincetown Art Association, 1930.

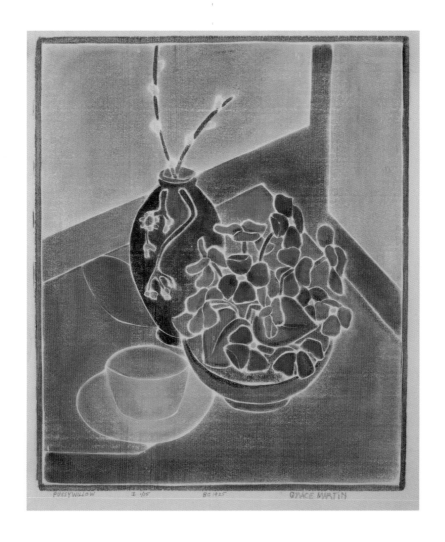

Pl. 4: *Pussy Willow*, ca. 1985-1988 (block cut 1925)
Color woodblock print on paper
Sheet size: 15 x 14 in. (38.1 x 35.6 cm.)
Image size: 13 ¾ x 12 in. (34.9 x 30.5 cm.)
2011.3.18
Marked: PUSSYWILLOW I 1/15 BC1925 GRACE MARTIN

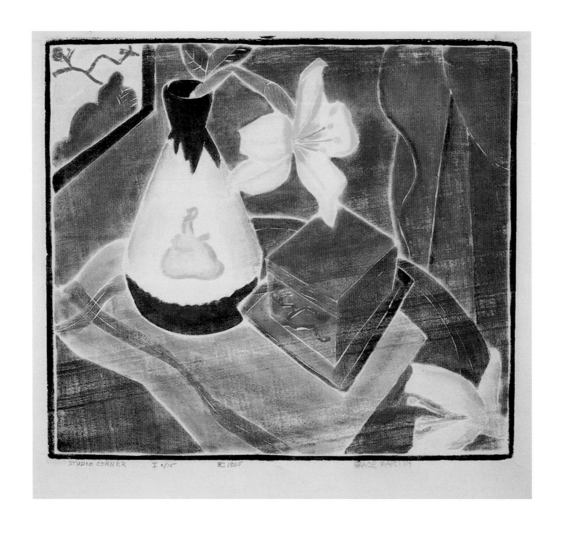

Pl. 5: **Studio Corner**, ca. 1985-1988 (block cut 1925)
Color woodblock print on paper
Sheet size: 15 x 15 ¾ in. (38.1 x 40 cm.)
Image size: 12 x 13 ¾ in. (30.5 x 34.9 cm.)
2011.3.22
Marked: STUDIO CORNER I 1/15 BC 1925 GRACE MARTIN

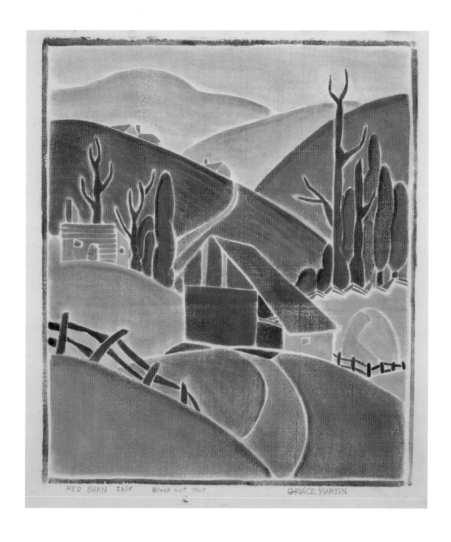

Pl. 6: ***Red Barn***, ca. 1985-1988 (block cut 1927)
Color woodblock print on paper
Sheet size: 16 x 15 in. (40.6 x 38.1 cm.)
Image size: 13 ¾ x 12 in. (34.9 x 30.5 cm.)
2011.3.17
Marked: RED BARN I 2/15 BLOCK CUT 1927 GRACE MARTIN

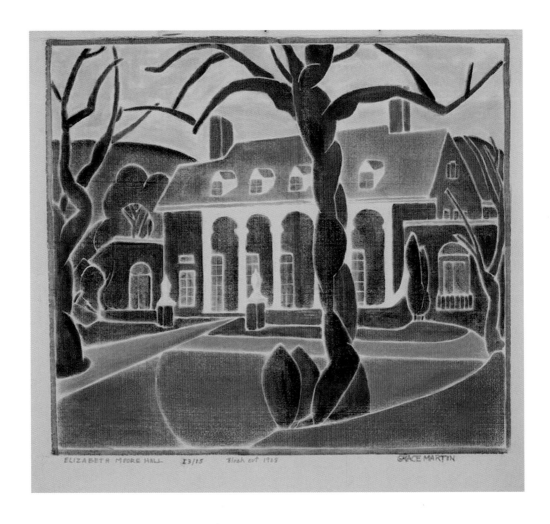

Pl. 7: ***Elizabeth Moore Hall***, ca. 1985-1988 (block cut 1928)
Color woodblock print on paper
Sheet size: 15 x 16 ¼ in. (38.1 x 41.3 cm.)
Image size: 11 7/8 x 13 ¾ in. (30.1 x 34.9 cm.)
1996.002.001
Marked: ELIZABETH MOORE HALL I 3/15 BLOCK CUT 1928
GRACE MARTIN

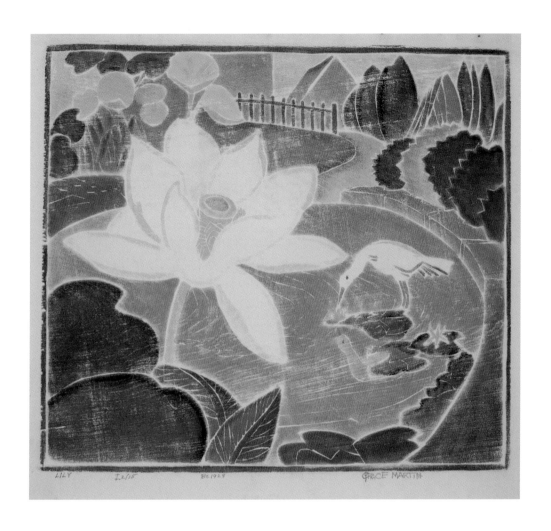

Pl. 8: *Lily*, ca. 1985-1988 (block cut 1928)
Color woodblock print on paper
Sheet size: 14 ¾ x 16 in. (37.5 x 40.6 cm.)
Image size: 13 ¾ x 12 in. (34.9 x 30.5 cm.)
2011.3.10
Marked: LILY I 2/15 BC1928 GRACE MARTIN

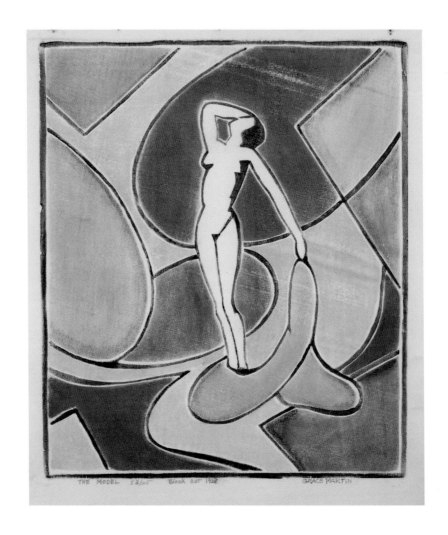

Pl. 9: *The Model*, ca. 1985-1988 (block cut 1928)
Color woodblock print on paper
Sheet size: 16 x 14 ¾ in. (40.6 x 37.5 cm.)
Image size: 13 ¾ x 12 in. (34.9 x 30.5 cm.)
2011.3.13
Marked: THE MODEL I 3/25 BLOCK CUT 1928 GRACE MARTIN

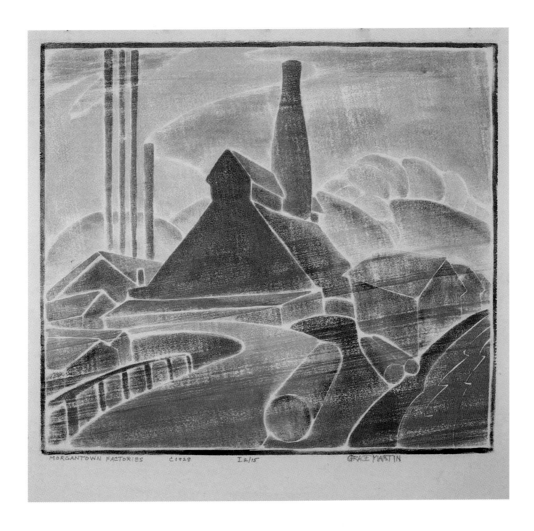

Pl. 10: ***Morgantown Factories***, ca. 1985-1988 (block cut 1928)
Color woodblock print on paper
Sheet size: 15 x 16 1/8 in. (38.1 x 41 cm.)
Image size: 11 7/8 x 13 11/16 in. (30.1 x 34.7 cm.)
1995.014.001
Marked: MORGANTOWN FACTORIES C1928 I 2/15 GRACE MARTIN

EXHIBITIONS:

West Virginia Vistas and Visionaries: Recent Accessions to the West Virginia University Art Collection, West Virginia University, Morgantown, West Virginia, 1995.

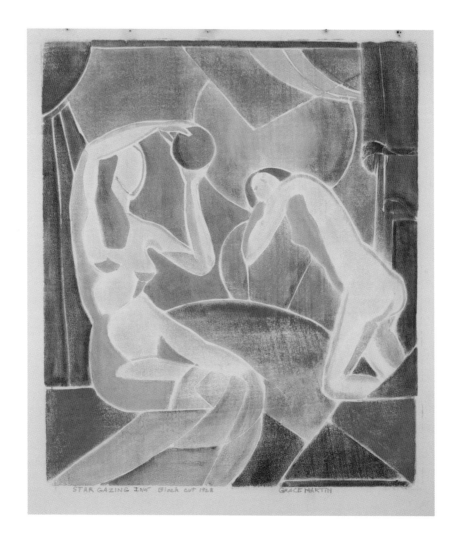

Pl. 11: **Star Gazing** [also known as *Nudes* and *Moon Glow*] ca. 1985-1988 (block cut 1928)
Color woodblock print on paper
Sheet size: 16 x 14 7/8 in. (40.6 x 37.8 cm.)
Image size: 13 ¾ x 12 in. (34.9 x 30.5 cm.)
2011.3.20
Marked: STAR GAZING I 3/15 BLOCK CUT 1928 GRACE MARTIN

EXHIBITIONS:

R. H. Macy's & Co., New York, New York, 1931 (exhibited as *Nudes*).

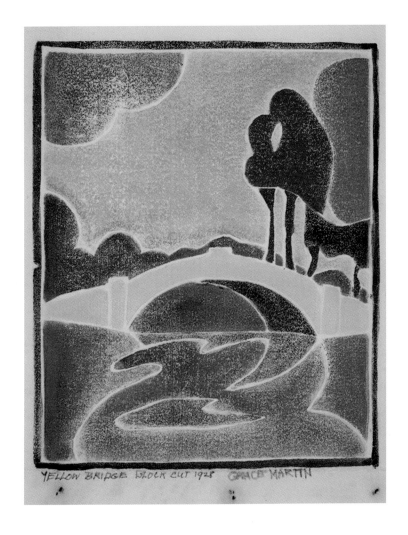

Pl. 12: *Yellow Bridge*, ca. 1985-1988 (block cut 1928)
Color woodblock print on paper
Sheet size: 8 7/8 x 6 ½ in. (22.5 x 16.5 cm.)
Image size: 6 7/8 x 5 ¾ in. (17.5 x 14.6 cm.)
2011.12.1
Marked: YELLOW BRIDGE BLOCK CUT 1928 GRACE MARTIN

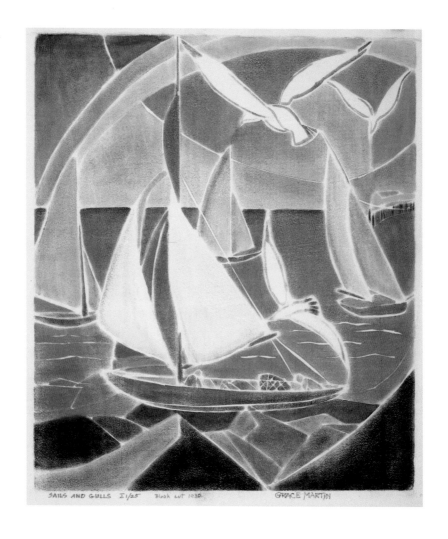

Pl. 13: ***Sails and Gulls***, ca. 1985-1988 (block cut 1930)
Color woodblock print on paper
Sheet size: 16 ½ x 15 in. (41.9 x 38.1 cm.)
Image size: 13 ¾ x 11 7/8 in. (34.9 x 30.1 cm.)
1997.001.001
Marked: SAILS AND GULLS I 1/25 BLOCK CUT 1930 GRACE MARTIN

EXHIBITIONS:

Provincetown Printers: A Woodcut Tradition, National Museum of American Art, Smithsonian Institution, Washington, D.C., 1983-84.

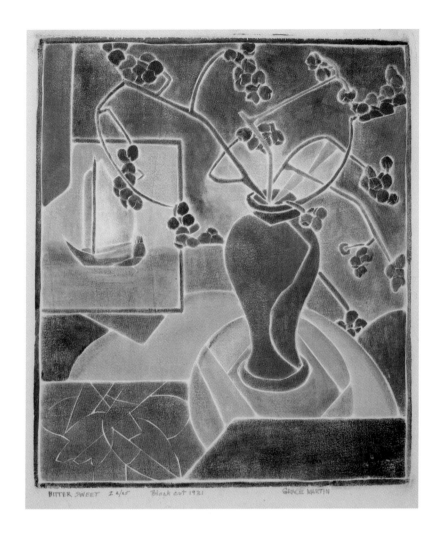

Pl. 14: ***Bitter Sweet***, ca. 1985-1988 (block cut 1931)
Color woodblock print on paper
Sheet size: 16 ¼ x 14 7/8 in. (41.3 x 37.8 cm.)
Image size: 13 ¾ x 11 7/8 in. (34.9 x 30.1 cm.)
2011.3.2
Marked: BITTER SWEET I 2/25 BLOCK CUT 1931 GRACE MARTIN

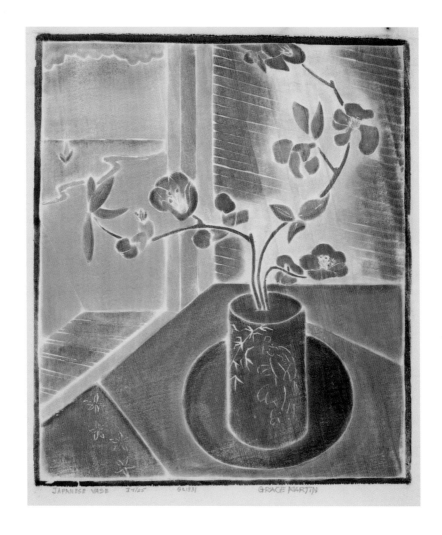

Pl. 15: ***Japanese Vase***, ca. 1985-1988 (block cut 1931)
Color woodblock print on paper
Sheet size: 16 ¼ x 15 in. (41.3 x 38.1 cm.)
Image size: 13 ¾ x 12 in. (34.9 x 30.5 cm.)
2011.3.9
Marked: JAPANESE VASE I 4/25 BC1931 GRACE MARTIN

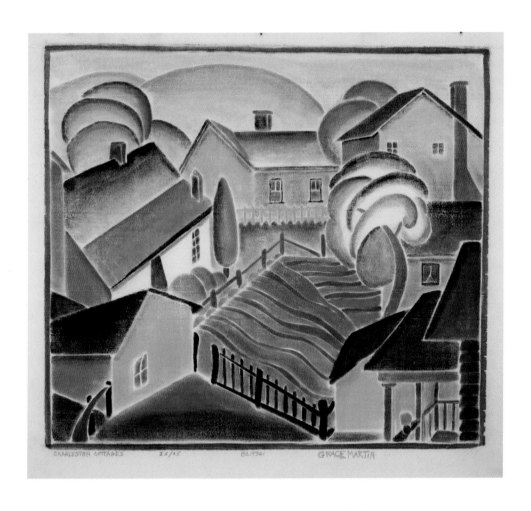

Pl. 16: ***Charleston Cottages***, ca. 1985-1988 (block cut 1932)
Color woodblock print on paper
Sheet size: 14 7/8 x 16 in. (37.8 x 40.6 cm.)
Image size: 12 x 13 11/16 in. (30.5 x 34.7 cm.)
2011.3.4
Marked: CHARLESTON COTTAGES I 5/25 BC1932 GRACE MARTIN

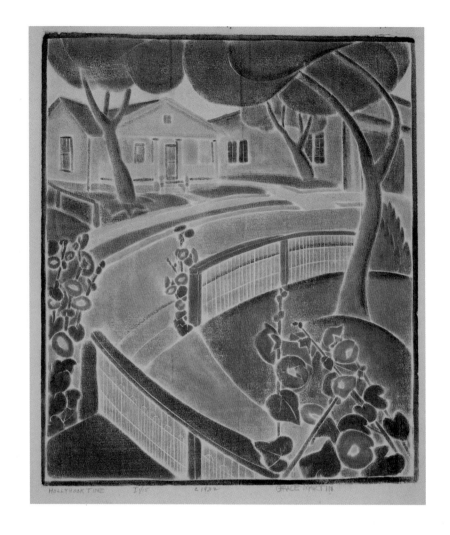

Pl. 17: ***Hollyhock Time***, ca. 1985-1988 (block cut 1932)
Color woodblock print on paper
Sheet size: 16 x 14 7/8 in. (40.6 x 37.8 cm.)
Image size: 13 11/16 x 11 7/8 in. (34.7 x 30.1 cm.)
2011.3.8
Marked: HOLLYHOCK TIME I 1/15 C1932 GRACE MARTIN

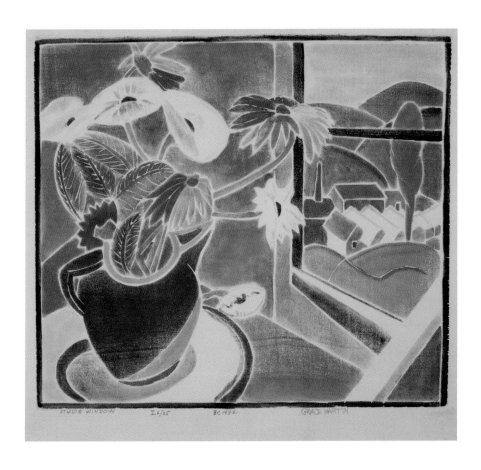

Pl. 18: **Studio Window**, ca. 1985-1988 (block cut 1932)
Color woodblock print on paper
Sheet size: 15 x 15 7/8 in. (38. 1 x 40.3 cm.)
Image size: 12 x 13 ¾ in. (30.5 x 34.9 cm.)
2011.3.23
Marked: STUDIO WINDOW I 6/25 BC1932 GRACE MARTIN

EXHIBITIONS:

8th Modern Exhibition, Provincetown Art
Association, 1932.

50 Best Color Prints in USA & Canada, Printmakers
Club of California, 1933.

Corcoran Gallery, Washington, D.C., 1940.

Artists for Victory, Metropolitan Museum of Art,
New York, New York, 1942-1943.

Purchased by American Color Print Society and
presented to the Kanawha County Public
Library, 1944.

Virginia Intermont College, Bristol, Virginia, 1953.

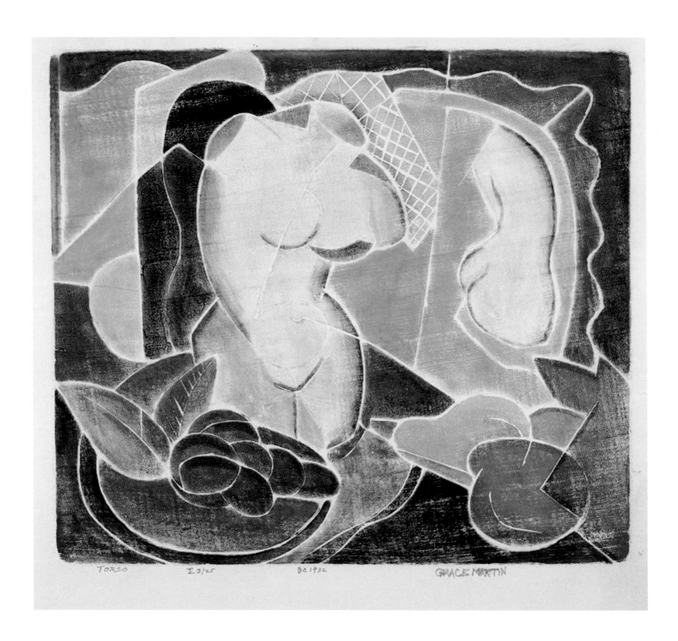

TORSO I 3/25 BC 1932 GRACE MARTIN

Pl. 19: **Torso** [also known as *Pink Torso*], ca. 1985-1988 (block cut 1932)
Color woodblock print on paper
Sheet size: 15 x 15 ¾ in. (38.1 x 40 cm.)
Image size: 12 x 13 ¾ in. (30.5 x 34.9 cm.)
2011.3.24
Marked: TORSO I 3/25 BC1932 GRACE MARTIN

EXHIBITIONS:

Corcoran Gallery, Washington, D.C., 1940.

American Watercolor Society, 1940.

Washington Watercolor Club, Washington, D.C., 1944.

Ohio University, Athens, Ohio, 1945.

National Academy of Design, New York, New York, 1946, 1948.

Fifth Annual Regional Exhibition of Oils, Water Colors, and Prints, Intermont College, Bristol, Virginia, 1948.

Received 1st Prize in prints by judge Sheldon Cheney for *Pink Torso*.

Society of Four Arts, Palm Beach, Florida, 1950.

Solo Exhibition, Laskin Galleries, Charleston, West Virginia, 1957.

Solo Exhibition, Artist of the Year, West Virginia University, 1958.

Denver Museum, Living Arts Center, Denver, Colorado, 1960.

Charleston Art Gallery, Charleston, West Virginia, 1960.

Centennial of West Virginia University, 1967.

West Virginia Cultural Center, Charleston, West Virginia, 1981-82.

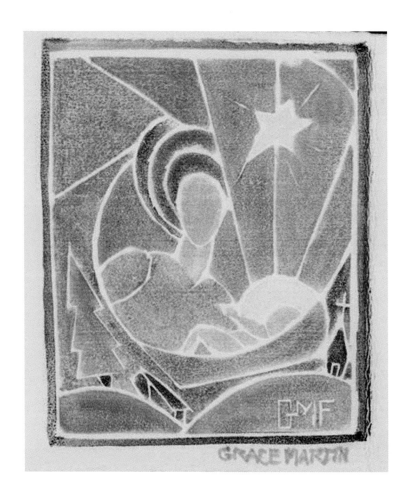

Pl. 20: **untitled** [Madonna and Child], ca. 1985-1988 (block cut, ca. 1932)
Color woodblock print on paper
Sheet size: 4 ½ x 4 5/16 in. (11.4 x 11 cm.)
Image size: 4 x 3 3/8 in. (10.2 x 8.6 cm.)
2011.12.2
Signed in image: GMF
Marked: GRACE MARTIN

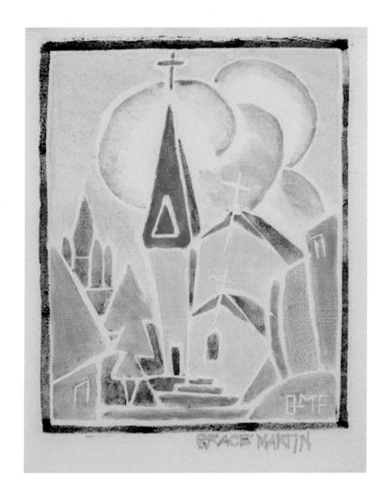

Pl. 21: ***untitled*** [Trinity Episcopal Church], ca. 1985-1988 (block cut, ca. 1932)
Color woodblock print on paper
Sheet size: 5 3/8 x 4 ¼ in. (13.7 x 10.8 cm.)
Image size: 4 ¼ x 3 ½ in. (10.8 x 8.9 cm.)
2011.12.3
Signed in image: GMF
Marked: GRACE MARTIN

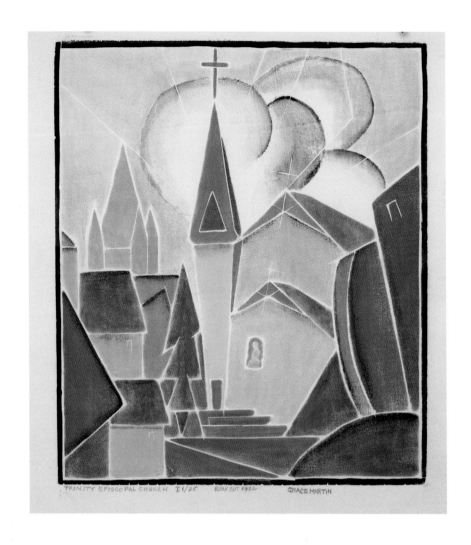

Pl. 22: *Trinity Episcopal Church*, ca. 1985-1988 (block cut 1932)
Color woodblock print on paper
Sheet size: 15 ¾ x 15 in. (40 x 38.1 cm.)
Image size: 13 ¾ x 12 in. (34.9 x 30.5 cm.)
2011.3.25
Marked: TRINITY EPISCOPAL CHURCH I 1/25 BLOCK CUT 1932
GRACE MARTIN

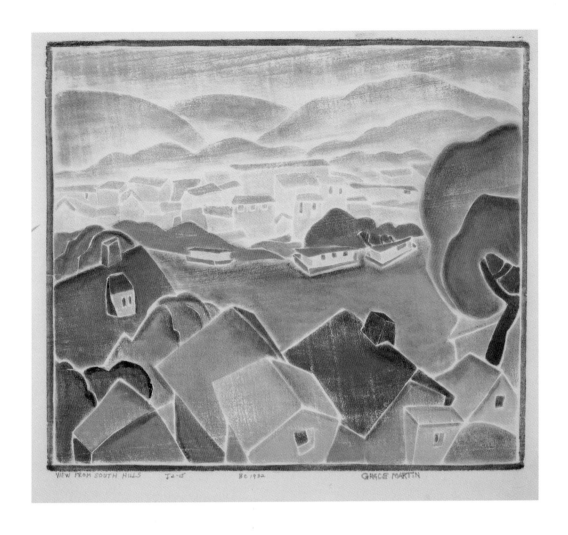

Pl. 23: ***View from South Hills***, ca. 1985-1988 (block cut 1932)
Color woodblock print on paper
Sheet size: 15 x 15 ¾ in. (38.1 x 40 cm.)
Image size: 12 x 13 ¾ in. (30.5 x 34.9 cm.)
2011.3.26
Marked: VIEW FROM SOUTH HILLS I 2-15 BC1932 GRACE MARTIN

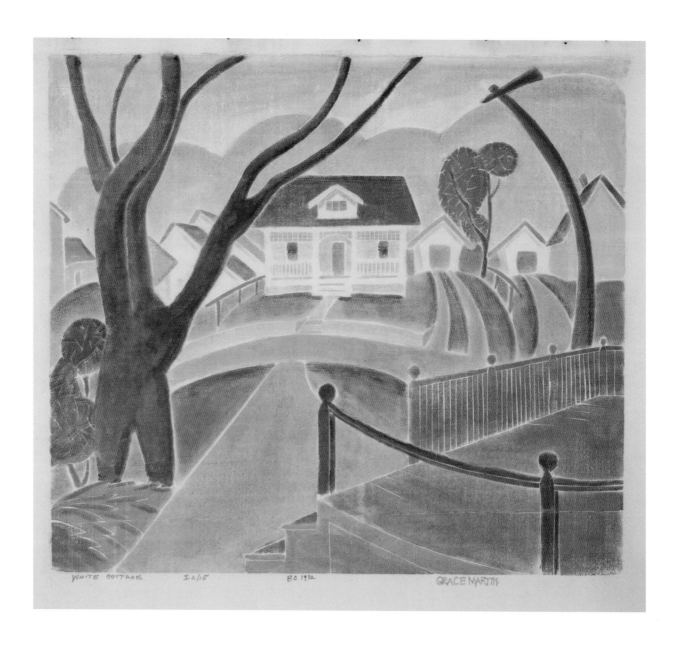

WHITE COTTAGE I 2/15 BC 1932 GRACE MARTIN

50

Pl. 24: **White Cottage**, ca. 1985-1988 (block cut 1932)
Color woodblock print on paper
Sheet size: 14 7/8 x 15 7/8 in. (37.8 x 40.3 cm.)
Image size: 12 x 13 ¾ in. (30.5 x 34.9 cm.)
2011.3.27
Marked: WHITE COTTAGE I 2/15 BC1932 GRACE MARTIN

EXHIBITIONS:

8th Modern Exhibition, Provincetown Art Association, 1932.

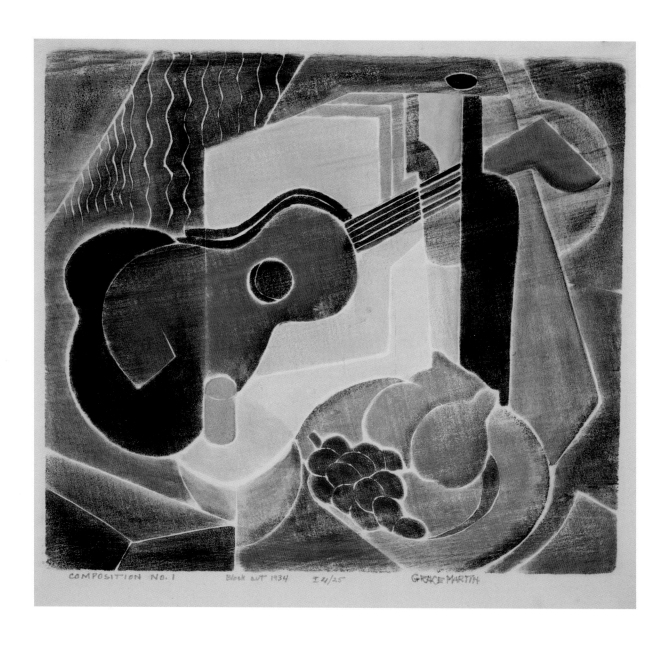

COMPOSITION No. 1 Block cut 1934 I 4/25 GRACE MARTIN

Pl. 25: ***Composition No. 1***, ca. 1985-1988 (block cut 1934)
Color woodblock print on paper
Sheet size: 15 x 16 in. (38.1 x 40.6 cm.)
Image size: 11 7/8 x 13 ¾ in. (30.1 x 34.9 cm.)
2011.3.5
Marked: COMPOSITION NO. 1 BLOCK CUT 1934 I 4/25 GRACE MARTIN

EXHIBITIONS:

Oakland Art Gallery, Oakland, California, 1942.

Corcoran Gallery, Washington, D.C., 1942.

American Color Print Society, 1942.

Washington Water Color Club, Washington D.C., 1942.

Artists for Victory, Metropolitan Museum of Art, New York, New York, 1942-43.

Library of Congress, Washington, D.C., 1944.

American Watercolor Society, National Academy of Design, New York, New York, 1944.

Mint Museum, Charlotte, North Carolina, 1946.

Fifth Annual Regional Exhibition of Oils, Water Colors, and Prints, Intermont College, Bristol, Virginia, 1948.

Society of Four Arts, Palm Beach, Florida, 1950.

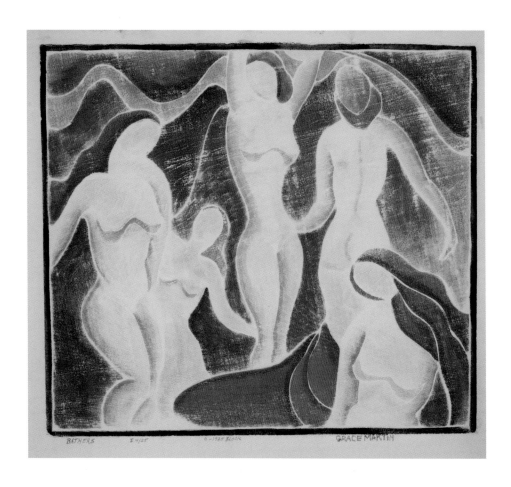

Pl. 26: **Bathers**, ca. 1985-1988 (block cut 1935)
Color woodblock print on paper
Sheet size: 15 x 15 7/8 in. (38.1 x 40.3 cm.)
Image size: 11 7/8 x 13 ¾ in. (30.1 x 34.9 cm.)
2011.3.1
Marked: BATHERS I 4/25 C-1935 BLOCK GRACE MARTIN

EXHIBITIONS:

American Color Print Society, 1944.

Virginia Intermont College, Bristol, Virginia, 1949.

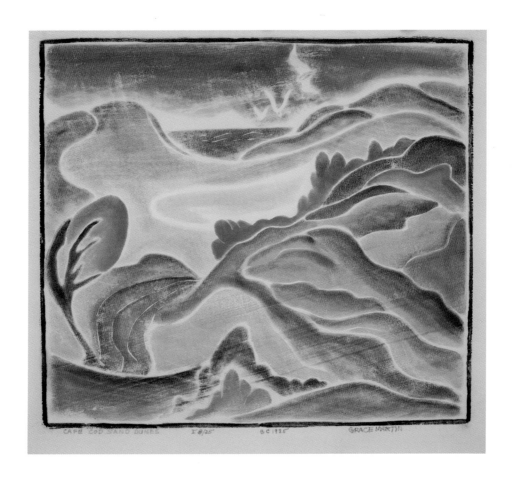

Pl. 27: *Cape Cod Sand Dunes*, ca. 1985-1988 (block cut 1935)
Color woodblock print on paper
Sheet size: 15 x 16 ¼ in. (38.1 x 41.3 cm.)
Image size: 11 7/8 x 13 ¾ in. (30.1 x 34.9 cm.)
2011.3.3
Marked: CAPE COD SAND DUNES I 8/25 BC1935 GRACE MARTIN

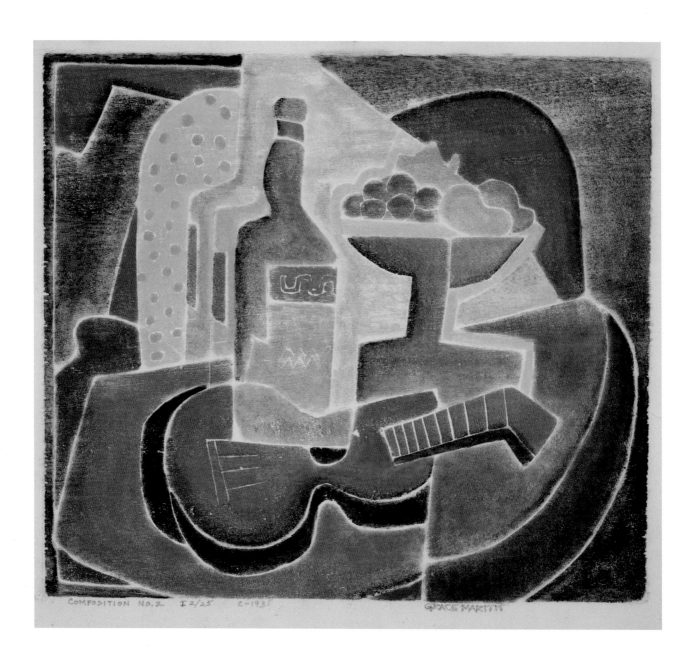

COMPOSITION NO. 2 I 2/25 C-1935 GRACE MARTIN

Pl. 28: ***Composition No. 2***, ca. 1985-1988 (block cut 1935)
Color woodblock print on paper
Sheet size: 15 x 16 ½ in. (38.1 x 41.9 cm.)
Image size: 11 7/8 x 13 ¾ in. (30.1 x 34.9 cm.)
1997.001.002
Marked: COMPOSITION NO. 2 I 2/25 C-1935 GRACE MARTIN

EXHIBITIONS:

Oakland Art Gallery, Oakland, California, 1942.

American Color Print Society, 1942.

Washington Watercolor Club, Washington, D.C., 1942.

Corcoran Gallery, Washington, D.C., 1942.

Library of Congress, Washington, D.C., 1944.

Mint Museum, Charlotte, North Carolina, 1946.

Brooklyn Museum, Brooklyn, New York, 1947.

Fifth Annual Regional Exhibition of Oils, Water Colors, and Prints, Intermont College, Bristol, Virginia, 1948.

WVU Art Collection Recent Regional Acquisitions, West Virginia University, Morgantown, West Virginia, 1997.

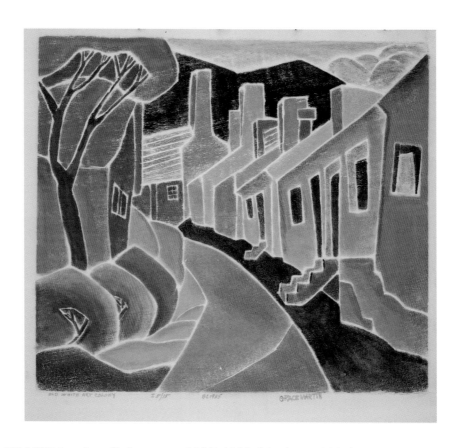

Pl. 29: ***Old White Art Colony***, ca. 1985-1988 (block cut 1935)
Color woodblock print on paper
Sheet size: 15 x 15 ¾ in. (38.1 x 40 cm.)
Image size: 12 x 13 ¾ in. (30.5 x 34.9 cm.)
2011.3.15
Marked: OLD WHITE ART COLONY I 5/15 BC1935 GRACE MARTIN

EXHIBITIONS:

Southern Printmakers, 1942.

American Color Print Society, 1942.

Washington Watercolor Club, Washington, D.C., 1944.

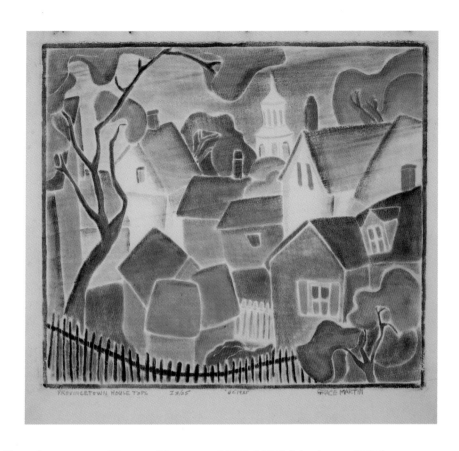

Pl. 30: ***Provincetown House Tops***, ca. 1985-1988 (block cut 1935)
Color woodblock print on paper
Sheet size: 15 x 16 in. (38.1 x 40.6 cm.)
Image size: 12 x 13 ¾ in. (30.5 x 34.9 cm.)
2011.3.16
Marked: PROVINCETOWN HOUSE TOPS I 3/25 BC1935 GRACE MARTIN

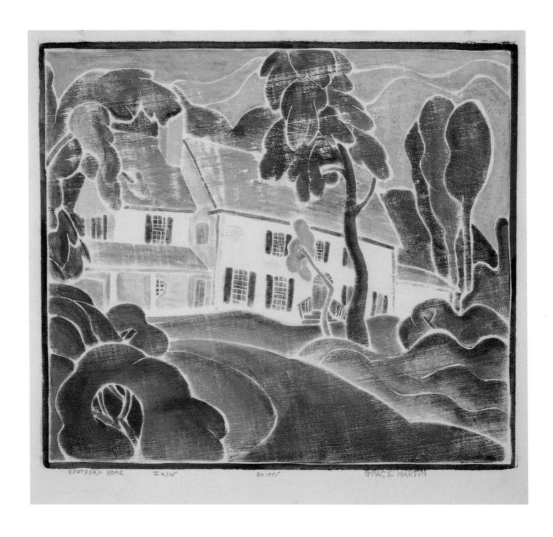

Pl. 31: **Southern Home**, ca. 1985-1988 (block cut 1935)
Color woodblock print on paper
Sheet size: 15 x 15 7/8 in. (38.1 x 40.3 cm.)
Image size: 12 x 13 ¾ in. (30.5 x 34.9 cm.)
2011.3.19
Marked: SOUTHERN HOME I 2/15 BC1935 GRACE MARTIN

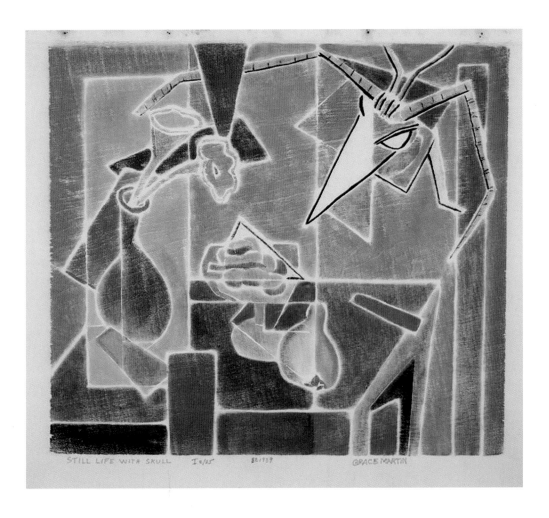

Pl. 32: ***Still Life with Skull***, ca. 1985-1988 (block cut 1939)
Color woodblock print on paper
Sheet size: 15 x 16 in. (38.1 x 40.6 cm.)
Image size: 12 x 13 ¾ in. (30.5 x 34.9 cm.)
2011.3.21
Marked: STILL LIFE WITH SKULL I 2/25 BC1939 GRACE MARTIN

EXHIBITIONS:

Allied Artists of West Virginia, Charleston, West Virginia, 1943, 1944.

American Color Print Society, 1944.

Virginia Intermont College, Bristol, Virginia, 1945.

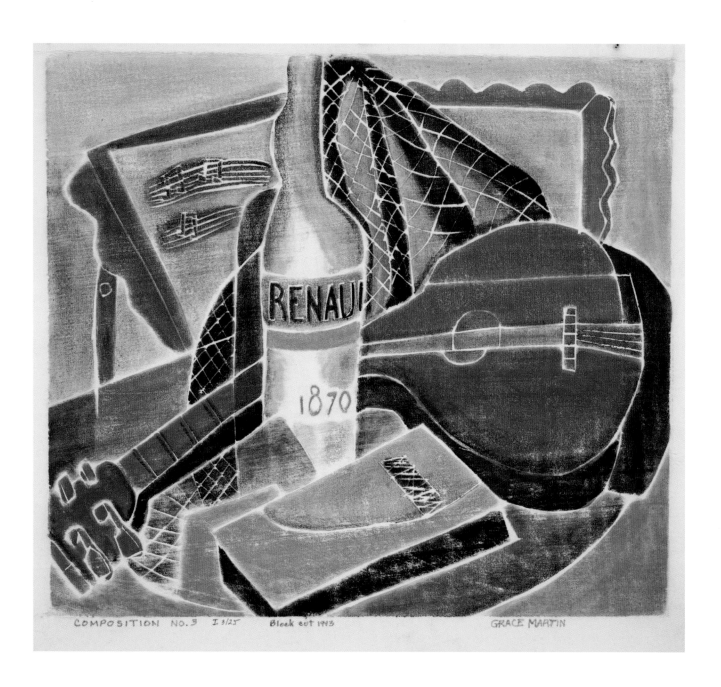

COMPOSITION NO. 3 I 3/25 Block cut 1943 GRACE MARTIN

Pl. 33: ***Composition No. 3***, ca. 1985-1988 (block cut 1943)
Color woodblock print on paper
Sheet size: 15 x 16 in. (38.1 x 40.6 cm.)
Image size: 12 x 13 ¾ in. (30.5 x 34.9 cm.)
2011.3.6
Marked: COMPOSITION NO. 3 I 3/25 BLOCK CUT 1943 GRACE MARTIN

EXHIBITIONS:

American Color Print Society, 1943.

Allied Artists of West Virginia exhibition, Sheldon Cheney, judge, selected *Composition No. 3* for
first prize in prints, 1945.

National Academy of Design, New York, New York, 1946.

Brooklyn Museum, Brooklyn, New York, 1947.

Oakland Art Gallery, Oakland, California, 1948.

Washington Watercolor Club, Washington, D.C., 1948.

Virginia Intermont College, Bristol, Virginia, 1949.

American Painting Today, Metropolitan Museum of Art, New York, New York, 1952.

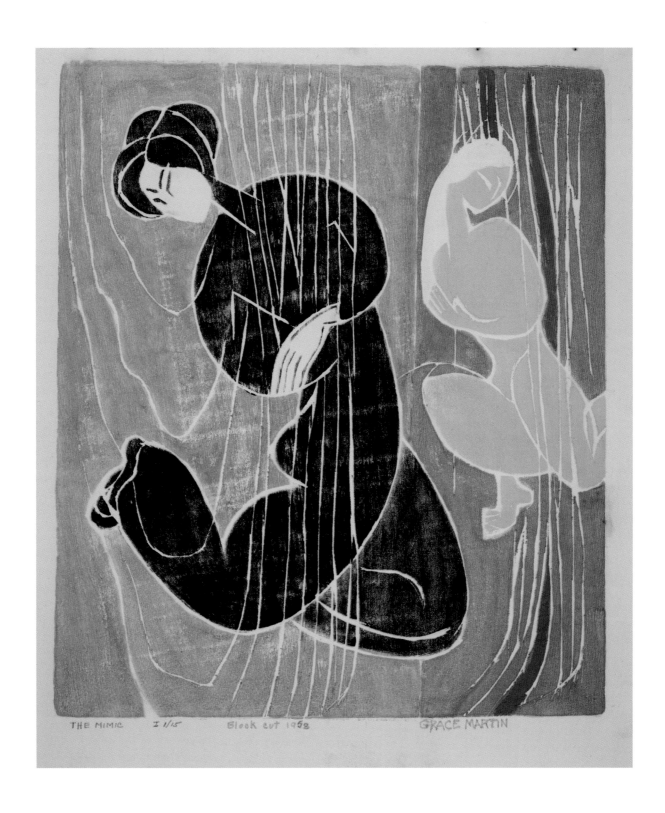

THE MIMIC I 1/15 Block cut 1958 GRACE MARTIN

Pl. 34: ***The Mimic***, ca. 1985-1988 (block cut 1958)
Color woodblock print on paper
Sheet size: 16 x 14 7/8 in. (40.6 x 37.8 cm.)
Image Size: 13 ¾ x 12 in. (34.9 x 30.5 cm.)
2011.3.12
Marked: THE MIMIC I 1/15 BLOCK CUT 1958 GRACE MARTIN

EXHIBITIONS:

Speed Art Museum, Louisville, Kentucky, 1973.

Davidson National Print & Drawing Competition, Davidson College, North Carolina, 1974.

Charleston Art Gallery, Charleston, West Virginia, 1975.

Provincetown Art Association, 1978.

Pl. 35: ***Cape Cod***, 1943
Sheet size: 3 ¼ x 4 in. (8.3 x 10.2 cm.)
Image size: 2 ¾ x 3 ½ in. (7 x 8.9 cm.)
2015.3.5
Marked: Cape Cod G. Frame '43

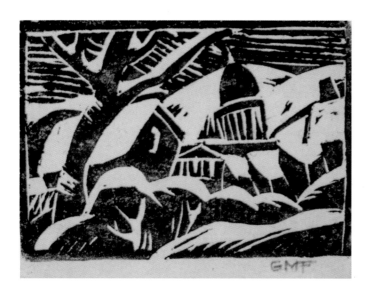

Pl. 36: ***untitled***, 1935
Linoleum block print on paper
Sheet size: 3 x 4 in. (7.6 x 10.2 cm.)
Image size: 2 ¾ x 4 in. (7 x 10.2 cm.)
2015.3.9
Marked: GMF

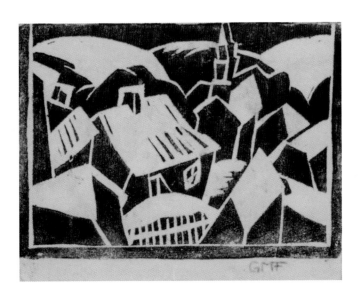

Pl. 37: ***untitled***, 1936
Linoleum block print with collage on paper
Sheet size: 3 x 4 in. (7.6 x 10.2 cm.)
Image size: 2 ¾ x 4 in. (7 x 10.2 cm.)
2015.3.6
Marked: GMF

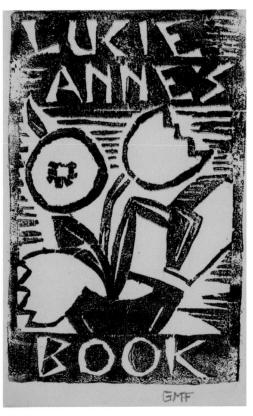

Pl. 38: ***Lucie Anne's Book***, ca. 1936-1939
Linoleum block print on paper
Sheet size: 4 ¼ in. x 2 ¾ in. (10.8 x 7 cm.)
Image size: 4 x 2 ½ in. (10.2 x 6.4 cm.)
2015.3.3
Marked: GMF

Pl. 39: ***Lucie at Piano***, 1938
Linoleum block print on paper
Sheet size: 3 ¾ x 2 ¾ in. (9.5 x 7 cm.)
Image size: 4 ½ x 3 in. (11.4 x 7.6 cm.)
2015.3.25
Marked: GMF

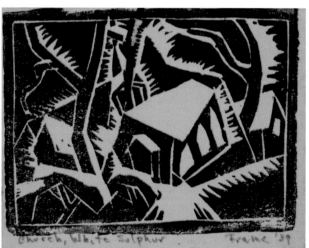

Pl. 40: ***Church, White Sulphur***, 1939
Linoleum block print on paper
Sheet size: 3 x 4 in. (7.6 x 10.2 cm.)
Image size: 2 ¾ x 3 ¾ in. (7 x 9.5 cm.)
2015.3.7
Marked: Church, White Sulphur Frame '39

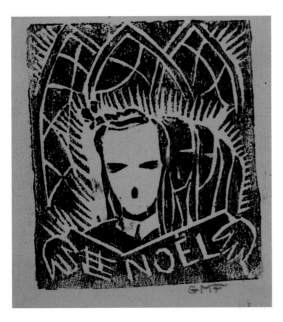

Pl. 41: ***Lucie Singing***, 1941
Linoleum block print on paper
Sheet size: 3 ½ x 3 ½ in. (8.9 x 8.9 cm.)
Image size: 3 x 2 ¾ in. (7.6 x 7 cm.)
2015.3.11
Marked: GMF

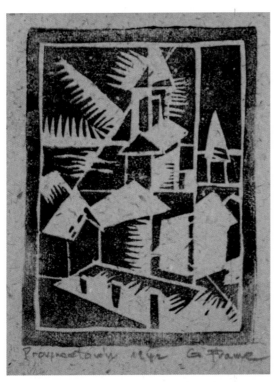

Pl. 42: ***Provincetown***, 1942
Linoleum block print on paper
Sheet size: 4 x 3 ½ in. (10.2 x 8.9 cm.)
Image size: 3 ½ x 2 ¾ in. (8.9 x 7 cm.)
2015.3.23
Marked: Provincetown 1942 G. Frame

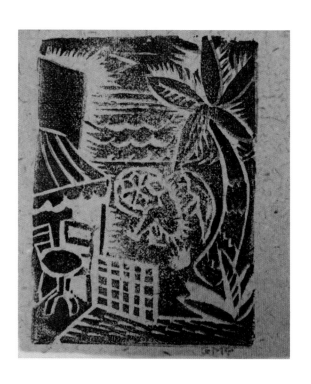

Pl. 43: *Florida*, 1944
Linoleum block print on paper
Sheet size: 3 ¾ x 3 ½ in. (9.5 x 8.9 cm.)
Image size: 3 ½ x 2 ¾ in. (8.9 x 7 cm.)
2015.3.2
Marked: GMF

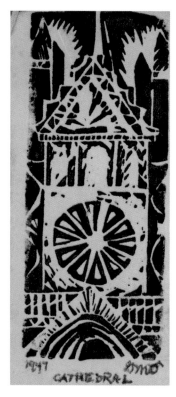

Pl. 44: *Cathedral*, 1949
Linoleum block print on paper
Sheet size: 4 ¼ x 2 in. (10.8 x 5.1 cm.)
Image size: 3 ½ x 1 ½ in. (8.9 x 3.8 cm.)
2015.3.1
Marked: 1949 Cathedral GMT
Verso bottom left: 1949
Verso bottom right: Grace

Pl. 45: ***untitled***, after 1950
Linoleum block print on paper
Sheet size: 4 x 2 ¼ in. (10.2 x 5.7 cm.)
Image size: 3 x 1 ½ in. (7.6 x 3.8 cm.)
2015.3.22
Marked: GMT

Pl. 46: ***Taos***, 1955
Linoleum block print on paper
Sheet size: 2 ¼ x 5 in. (5.7 x 12.7 cm.)
Image size: 1 ½ x 4 ¼ in. (3.8 x 10.8 cm.)
2015.3.4
Marked: Taos GMT 1955

Pl. 47: ***untitled***, 1958
Linoleum block print on paper
Sheet size: 4 ½ x 2 in. (11.4 x 5.1 cm.)
Image size: 3 ½ x 1 ½ in. (8.9 x 3.8 cm.)
2015.3.21
Marked: GMT

Pl. 48: ***untitled***, 1959
Linoleum block print mounted on red paper
Sheet size: 4 ½ x 3 ¾ in. (11.4 x 9.5 cm.)
Image size: 3 ¾ x 1 ½ in. (9.5 x 3.8 cm.)
2015.3.26a
Marked: GMT

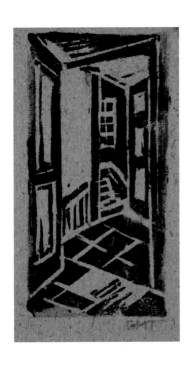

Pl. 49: **untitled**, 1963
Linoleum block print on paper
Sheet size: 4 x 2 in. (10.2 x 5.1 cm.)
Image size: 3 ¼ x 1 ½ in. (8.3 x 3.8 cm.)
2015.3.12a
Marked: GMT

Pl. 50: **untitled**, 1965
Linoleum block print on paper
Sheet size: 4 ½ x 3 in. (11.4 x 7.6 cm.)
Image size: 4 x 2 ¾ in. (10.2 x 7 cm.)
2015.3.10
Marked: GMT

Pl. 51: *untitled*, 1967
Linoleum block print on paper, hand colored
Sheet size: 4 ½ x 3 in. (11.4 x 7.6 cm.)
Image size: 4 x 2 ¾ in. (10.2 x 7 cm.)
2015.3.27b
Marked: GMT

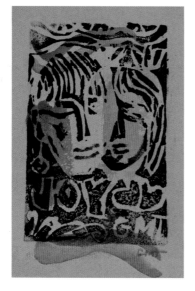

Pl. 52: *untitled*, 1968
Linoleum block print on paper, hand colored
Sheet size: 4 x 3 in. (10.2 x 7.6 cm.)
Image size: 3 x 2 in. (7.6 x 5.1 cm.)
2015.3.14a
Marked: GMT

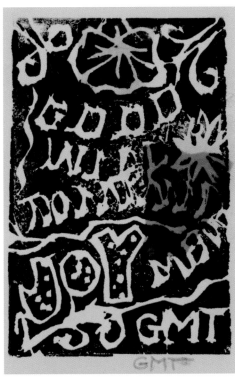

Pl. 53: ***untitled***, 1968
Linoleum block print with collage on paper
Sheet size 3 ½ x 2 ½ in. (8.9 x 6.4 cm.)
Image size: 3 x 2 in. (7.6 x 5.1 cm.)
2015.3.8b
Marked: GMT

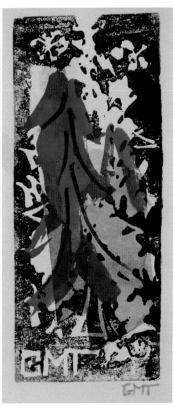

Pl. 54: ***untitled***, 1968
Linoleum block print with collage on paper,
hand colored
Mounted on green paper
Sheet size: 4 ½ x 2 in. (11.4 x 5.1 cm.)
Image size: 4 x 1 ½ in. (10.2 x 3.8 cm.)
2015.3.15
Marked: GMT
Verso: Wishing you joy on Christmas,
With Love, Mother
Lucie, Bill, Jimmy

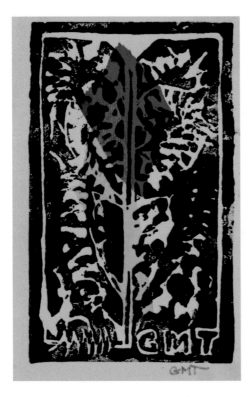

Pl. 55: ***untitled***, 1969
Linoleum block print on paper, hand colored
Sheet size: 4 ½ x 3 in. (11.4 x 7.6 cm.)
Image size: 4 x 2 ½ in. (10.2 x 6.4 cm.)
2015.3.24
Marked: GMT

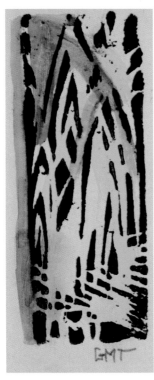

Pl. 56: ***untitled***, n.d.
Linoleum block print on paper, hand colored
Sheet size: 4 ½ x 2 in. (11.4 x 5.1 cm.)
Image size: 3 ¾ x 1 ½ in. (9.5 x 3.8 cm.)
2015.3.13b
Marked: GMT

Pl. 57: ***untitled***, n.d.
Linoleum block print on paper
Sheet size: 4 x 3 in. (10.2 x 7.6 cm.)
Image size: 3 x 2 in. (7.6 x 5.1 cm.)
2015.3.16a
Marked: GMF

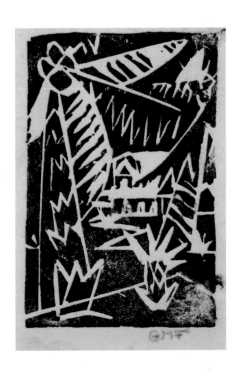

Pl. 58: ***untitled***, n.d.
Linoleum block print on paper
Sheet size: 3 ½ x 2 ¾ in. (8.9 x 7 cm.)
Image size: 3 x 2 in. (7.6 x 5.1 cm.)
2015.3.18
Marked: GMF

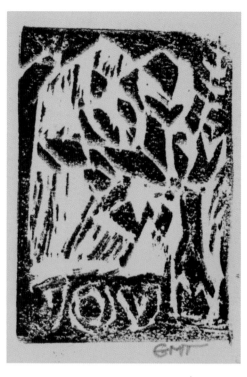

Pl. 59: **untitled**, n.d.
Linoleum block print on paper
Sheet size: 3 ½ x 2 ¾ in. (8.9 x 7 cm.)
Image size: 2 ½ x 2 in. (6.4 x 5.1 cm.)
2015.3.19
Marked: GMT

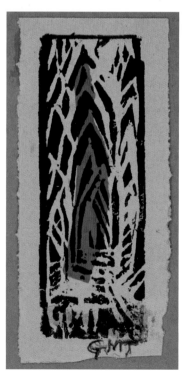

Pl. 60: **untitled**, n.d.
Linoleum block print mounted on red paper
Sheet size: 4 ½ x 2 in. (11.4 x 5.1 cm.)
Image size: 4 x 1 ½ in. (10.2 x 3.8 cm.)
2015.3.20
Marked: GMT

Pl. 61: ***untitled***, n.d.
Linoleum block print on paper
Sheet size: 4 x 2 ½ in. (10.2 x 6.4 cm.)
Image size: 3 ¼ x 1 ¾ in. (8.3 x 4.4 cm.)
2015.3.28a
Marked: GMT

Pl. 62: ***untitled***, n.d.
Linoleum block print on paper, hand colored
Sheet size: 4 ¾ x 3 ¼ in. (12.1 x 8.3 cm.)
Image size: 3 ¾ x 2 ¾ in. (9.5 x 7 cm.)
2015.3.29
Marked: GMT

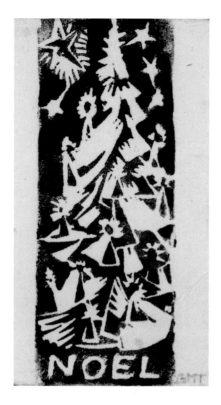

Pl. 63: *untitled*, n.d.
Linoleum block print on paper
Sheet size: 4 ¼ x 2 ¾ in. (10.8 x 7 cm.)
Image size: 4 ¼ x 1 ¾ in. (10.8 x 4.4 cm.)
2015.3.30
Marked: GMT

Pl. 64: *untitled*, n.d.
Linoleum block print on paper
Sheet size: 4 x 2 ¾ in. (10.2 x 7 cm.)
Image size: 3 ½ x 1 ½ in. (8.9 x 3.8 cm.)
2015.3.31a
Marked: GMT

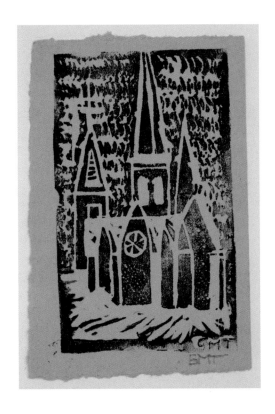

Pl. 65: *untitled*, n.d.
Linoleum block print on blue paper mounted
Sheet size: 4 ½ x 3 in. (11.4 x 7.6 cm.)
Image size: 3 ¼ x 2 ¼ in. (8.3 x 5.7 cm.)
2015.3.32
Marked: GMT

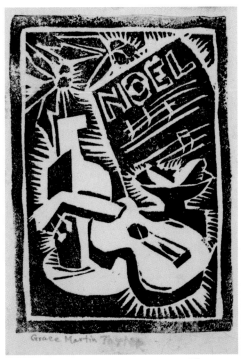

Pl. 66: *untitled*, n.d.
Linoleum block print on paper
Sheet size: 5 x 3 in. (12.7 x 7.6 cm.)
Image size: 3 3/8 x 2 ¼ in. (8.5 x 5.7 cm.)
2015.3.33
Marked: Grace Martin Taylor

Pl. 67: ***untitled***, n.d.
Linoleum block print on paper
Sheet size: 5 x 3 in. (12.7 x 7.6 cm.)
Image size: 3 ¼ x 1 ¼ in. (8.3 x 5.7 cm.)
2015.3.34
Marked: GMT

Pl. 68: ***untitled***, n.d.
Linoleum block print on paper
Sheet size: 4 ¾ x 3 in. (12.1 x 7.6 cm.)
Image size: 3 ¾ x 2 7/8 in. (9.5 x 7.3 cm.)
2011.12.4
Marked: Grace Martin

1869 Roxalana Rd

SELECTED CHRONOLOGY

1903

February 11, Grace Martin born in Cassville, West Virginia to Anna M. McClure and Joseph W. Martin

1922-1924

Pennsylvania Academy of Fine Arts, Philadelphia, Pennsylvania; 1923-24 study with Henry McCarter, Daniel Garber and Arthur B. Carles

1925

Private study with Blanche Lazzell, Morgantown, West Virginia

1928

West Virginia University, A.B. in English and Journalism

1929-1930

Private study with Blanche Lazzell, Provincetown, Massachusetts

1929-1942

Married to Wilber Frame (married 14 May 1929 in Morgantown, West Virginia, divorced 14 February 1942)

1930

Studied with Fritz Pfeiffer, Pfeiffer School of Art, Provincetown, Massachusetts
Group exhibitions: *4th Modern Exhibit*, Provincetown Art Association, Provincetown, Massachusetts; Boston Art Club, Boston, Massachusetts

1931

Group exhibition: *American Block Prints* at the Wichita Art Association, Wichita, Kansas

1931-1956

Mason College of Music & Fine Arts, Charleston, West Virginia. Head of Art Department, 1931-56; Administrative Assistant, 1950-53, Dean, 1953-55, President, 1955-56

1931-1981

Group annual exhibitions by the Allied Artists of West Virginia, Charleston, West Virginia, 1931, 1933-34, 1942, 1944-45, 1947-49, 1954-55, 1957-59, 1961, 1966-67, 1969, 1971-72, 1981

1932

Birth of daughter Lucie (6 June 1932) in Charleston, West Virginia
Group exhibition: Provincetown Art Association, Provincetown, Massachusetts

1933

Group exhibitions: *50 Best Color Prints in USA & Canada* at the Printmakers Club of California; *First Annual Exhibition of Contemporary Woodcuts* organized by The Woodcut Society in Kansas City, Missouri

1934

Group exhibitions: *8th Modern Exhibit*, Provincetown Art Association, Provincetown, Massachusetts; *The Woodcut*

Society, traveling exhibition through the Smithsonian Institution, Washington, D.C.

1937

Studied with Roy Hilton at the Carnegie Institute of Technology, Pittsburgh, Pennsylvania

1938-1941

Summer studies with William and Natalie Grauer at the Old White Art Colony, The Greenbrier resort, White Sulphur Springs, West Virginia

1939

Group exhibition: Oakland Art Gallery, Oakland, California

1940

Solo exhibitions: The Greenbrier resort, White Sulphur Springs, West Virginia; Richmond Professional Institute of the College of William and Mary, Richmond, Virginia
Group exhibitions: the Corcoran Gallery of Art, Washington, D.C.; Provincetown Art Association, Provincetown, Massachusetts

1940-1969

Group exhibition: American Watercolor Society at the National Academy of Design, New York, New York, 1940, 1946, 1949, 1958-63, 1965-69

1940-1979

Group exhibition: American Color Print Society, 1940, 1942-79

1942
Studied with Emil Bisttram at the Taos School of Art, Taos, New Mexico
Group exhibitions: Oakland Art Gallery, California; the Washington Watercolor Club, Washington, D.C.; Corcoran Gallery of Art, Washington, D.C.

1942-1943
Group exhibition: *Artists for Victory*, Metropolitan Museum of Art, New York, New York

1942-1957
Summer study at Hans Hofmann School of Fine Art, Provincetown, Massachusetts

1943
Group exhibition: Philadelphia Print Club, Philadelphia, Pennsylvania

1944
Group exhibition: Washington Watercolor Club, Washington, D.C.

1945
Solo exhibitions: Chubb Gallery, Ohio University, Athens, Ohio; The Greenbrier, White Sulphur Springs, West Virginia

1945-1953
Group exhibition: Intermont College, Bristol, Virginia, 1945-46, 1948-53

1946
Solo exhibition: Coyle Gallery
Group exhibitions: Mint Museum, Charlotte, North Carolina; Virginia Museum of Fine Arts, Richmond, Virginia; Parkersburg Art Center, Parkersburg, West

Virginia; Provincetown Art Association, Provincetown, Massachusetts

1947
Studied with Paul Weighart at the Art Institute of Chicago, Chicago, Illinois
Group exhibitions: Brooklyn Museum of Art, Brooklyn, New York; Boston Art Club, Boston, Massachusetts

1948
Group exhibitions: Washington Watercolor Club, Washington, D.C.; Coyle Gallery; Oakland Art Gallery, Oakland, California

1949
M.A. Master's Degree in Fine Arts, West Virginia University

1950
Group exhibitions: Society of the Four Arts, Palm Beach, Florida; *American Painting Today*, Metropolitan Museum, New York, New York

1951-1961
Married to William E. Taylor (married 1 August 1951 in Charleston, West Virginia, divorced 8 May 1961)

1951-1961
Group exhibition: *Ohio Valley Oil & Watercolor Show*, Athens, Ohio, 1951, 1953, 1955, 1957, 1959, 1961

1951, 1952
Studied with Raphael Gleitsman at the Akron Art Institute, Akron, Ohio

1952
Group exhibition: *American Painting Today*, Metropolitan Museum of Art, New York, New York

1952-1969

Group exhibition: *Exhibition 80*, Huntington Galleries, Huntington, West Virginia in 1952-55, 1959-65, 1969 [originally called *Exhibition 80*, later *Exhibition 180* and then *Exhibition 280*]

1956
Solo exhibitions: Press Club; West Virginia University, Morgantown, West Virginia
Group exhibition: Clarksburg Art Center, Clarksburg, West Virginia

1957
Solo exhibition: Lynn Laskin Galleries, Charleston, West Virginia

1957-1959
Studied with Will Barnett and Rudy Pozzatti at Ohio University, Athens, Ohio

1958
Solo exhibitions: *Paintings, Drawings and Color Woodcuts by Grace Martin Taylor*, Art Department of West Virginia University, Morgantown, West Virginia; Morris Harvey College, Charleston, West Virginia
Group exhibition: Abingdon Square Painters, New York, New York

1959
Group exhibitions: Charleston Civic Center, Charleston, West Virginia; Morris Harvey College, Charleston, West Virginia; Butler Institute of Art, Youngstown, Ohio

1960
Studied with Arnold Blanch at the Art Students League, New York, New York
Solo exhibition: Charleston Art Gallery, Charleston, West Virginia
Group exhibitions: Huntington Gallery (two-person), Huntington, West Virginia;

Morris Harvey College, Charleston, West Virginia; Denver Art Museum, Living Arts Center, Denver, Colorado

1961
Group exhibitions: Morris Harvey College, Charleston, West Virginia; *Second National Exhibition of Drawings & Prints*, Ohio University Gallery, Athens, Ohio; Charleston Art Gallery, Charleston, West Virginia; *Drawings USA*, St. Paul Gallery, St. Paul, Minnesota

1961-1972
Summers: studied at Davidson School of Modern Painting, New York, New York and Provincetown, Massachusetts

1962
Solo exhibition: Morris Harvey College, Charleston, West Virginia
Group exhibitions: *Collection of M. Lynn Laskin* at Charleston Art Gallery, Charleston, West Virginia

1963
Group exhibitions: Morris Harvey College, Charleston, West Virginia; *Centennial Exhibition*, Huntington Gallery, Huntington, West Virginia; *Ninth Annual Paintings of the Year*, University of Chicago, Chicago, Illinois; Watercolor USA, Springfield Art Museum, Springfield, Missouri; *First Annual Exhibition*, Charleston Art Gallery at the Sunrise Museum, Charleston, West Virginia

1964
Group exhibitions: Morris Harvey College, Charleston, West Virginia; Charleston Art Gallery, at Sunrise Museum, Charleston, West Virginia; Parkersburg Art Center, Parkersburg, West Virginia

1965
Group exhibitions: *American Drawing Biennial*, Norfolk Museum of Art, Norfolk, Virginia; *Jurors Show*, Huntington Gallery, Huntington, West Virginia; Morris Harvey College, Charleston, West Virginia; The Drawing Society, *Eastern Central Drawing Exhibition*, Philadelphia Museum of Art, Philadelphia, Pennsylvania; National Council of Jewish Women, Charleston Civic Center, Charleston, West Virginia

1966
Group exhibitions: Morris Harvey College, Charleston, West Virginia; *Bucknell National Drawing Exhibition*, Lewisburg, Pennsylvania; Montreat Gallery of Fine Art, Montreat-Anderson College, North Carolina; West Virginia University, Morgantown, West Virginia; Charleston Art Gallery, Charleston, West Virginia; *American Drawing Biennial*, Norfolk Museum, Norfolk, Virginia

1967
Solo exhibitions: Lively Import Gallery, Charleston, West Virginia; Montreat Gallery of Fine Art, Montreat-Anderson College, Montreat, North Carolina; Morgantown Art Association-West Virginia University Medical Center, Morgantown, West Virginia
Group exhibitions: *Appalachian Artists 67*, Ashland Community College of University of Kentucky, Ashland, Kentucky; Provincetown Art Association, Provincetown, Massachusetts; Charleston Art Gallery, Charleston, West Virginia; *Invitational Show*, Contemporary Gallery, Palm Beach, Florida; *Tri-State Annual*, Huntington, West Virginia

1968

Solo exhibitions: Morris Harvey College, Charleston, West Virginia
Group exhibitions: Provincetown Art Association, Provincetown, Massachusetts; East Coast Gallery; Charleston Art Gallery, Charleston, West Virginia; Society of the Four Arts, Palm Beach, Florida; *Tri-State Arts*, Ohio University, Athens, Ohio

1969
Group exhibitions: *American Drawing Biennial XXIII*, Norfolk Museum, Norfolk, Virginia; Provincetown Art Association, Provincetown, Massachusetts; Charleston Art Gallery, Charleston, West Virginia; Society of the Four Arts, Palm Beach, Flrida

1970
Group exhibition: East Coast Gallery

1973
Group exhibition: Charleston Art Gallery, Charleston, West Virginia

1974
Solo exhibition: West Virginia Capitol Complex, Charleston, West Virginia; Morris Harvey College, Charleston, West Virginia; Creative Arts Center, West Virginia University, Morgantown, West Virginia

1975
Group exhibition: Charleston Art Gallery, Charleston, West Virginia

1977
Group exhibition: *First National Drawing and Prints Competition*, School of Fine Arts, Miami University, Oxford, Ohio

1978
Group exhibition: Provincetown Art Association, Provincetown, Massachusetts

1980

Solo exhibition: Morris Harvey College, Charleston, West Virginia

Group exhibition: Provincetown Art Association, Provincetown, Massachusetts

1981-1982

Solo exhibition: *Grace Martin Taylor*, Cultural Center, Capitol Complex, Charleston, West Virginia ("Distinguished West Virginian" awarded by Governor John D. Rockefeller IV on 22 February 1982)

1982

Group exhibition: Oliphant and Company Fine Art and Antiques, New York, New York

1983

Group exhibition: *Provincetown Printers: A Woodcut Tradition*, curated by Janet Altaic Flint at the National Museum of American Art, Smithsonian Institution, Washington, D.C.

1987

Group exhibition: *American Prints 1900-1940*, Mary Ryan Gallery, New York, New York

1988

Group exhibition: *Provincetown Woodblock Whiteline Prints*, from the collection of Leslie J. Garfield, The Century Association, New York, New York

1989

"Mayor Awards for the Arts," Fund for the Arts, Charleston, West Virginia

1991

Solo exhibitions: *Grace Martin Frame Taylor: Works from 1925-1950*, Michael Lowe Gallery, Cincinnati, Ohio; University of Charleston, Charleston, West Virginia; West

Virginia State Museum, Charleston, West Virginia

1994

Group exhibition: Judy Robinson Gallery, Houston, Texas

1995

October 1, died in Charleston, West Virginia

Group exhibition: *West Virginia Vistas and Visionaries: Recent Accessions to the West Virginia University Art Collection*, West Virginia University, Morgantown, West Virginia

1996

Solo exhibition: *Grace Martin Taylor 1903-1995*, West Virginia University, Morgantown, West Virginia

1997

Solo exhibition: *A Woman of Substance: Remembering Grace Martin Taylor through her Paintings*, Morgan Peyton Fine Arts & Appraisal at Wheat First Butcher Singer, Charleston, West Virginia

Group exhibition: *West Virginia University Art Collection Recent Regional Acquisitions*, Morgantown, West Virginia

1998

Group exhibition: National Museum of Women in the Arts, Washington, D.C.

1999

Solo exhibition: *Grace Martin Taylor, Painter*, organized by the West Virginia State Museum, Cultural Center, Capitol Complex, Charleston, West Virginia

2000

Solo exhibitions: National Museum of Women in the Arts, Washington, D.C.; Museum in the Community, Hurricane,

West Virginia

Group exhibition: Huntington Museum of Art, Huntington, West Virginia

2001

Solo exhibition: *Grace Martin Taylor (1903-1995): An American Modernist*, The Orange Chicken Fine and Decorative Art Gallery, New York, New York

2002

Solo exhibition: *Grace Martin Taylor–Selected Works from 1903-1985*, The Art Store, Charleston, West Virginia

Group exhibitions: *From Paris to Provincetown: Blanche Lazzell and the Color Woodcut*, Museum of Fine Arts, Boston, Massachusetts– traveled to Cleveland Museum of Art, Cleveland, Ohio and Elvehjem Museum of Art-University of Wisconsin, Madison, Wisconsin; *Provincetown Women Artists*, ACME Fine Art and Design, Boston, Massachusetts

2005

Group exhibitions: *Striking the Right Notes: Music in American Art*, The Cahoon Museum of American Art, Cotuit, Massachusetts; ACME Fine Art, Boston, Massachusetts; Provincetown Art Association, Provincetown, Massachusetts

2006

Solo exhibition: *American Modernist: Grace Martin Taylor, 1903-1995*, The Art Store, Charleston, West Virginia; University of Charleston, Charleston, West Virginia

Group exhibition: ACME Fine Art, Boston, Massachusetts

2007

Solo exhibition: *Grace Martin Taylor: White-Line Woodblock Prints, Printing Blocks & Monotypes*, ACME Fine

Art, Boston, Massachusetts

2008

Group exhibitions: *Grace Martin Taylor, Selina Trieff, Blanche Lazzell–Students of Hans Hofmann*, The Art Store, Charleston, West Virginia; *The American Scene: Prints from Hopper to Pollock*, British Museum, London, England

2014

Group exhibition: *The Tradition of the Provincetown Print*, Provincetown Art Association, Provincetown, Massachusetts

2016

Solo exhibition: *Studio Window: The Prints of Grace Martin Taylor*, curated by Robert Bridges, Art Museum of West Virginia University, Morgantown, West Virginia

PUBLIC COLLECTIONS

American Color Print Society

Art Museum of West Virginia University, Morgantown, West Virginia

British Museum, London, England

Charleston Art Gallery, Charleston, West Virginia

The Clay Center–Juliet Museum of Art, Charleston, West Virginia

Greenville County Museum of Art, Greenville, South Carolina

Hallmark Co.

Huntington Museum of Art, Huntington, West Virginia

Kanawha County Public Library, Charleston, West Virginia

Laskin Galleries, Charleston, West Virginia

Library of Congress, Washington, D.C.

MacFarland Collection

McNay Art Museum, Texas

Miami University, Oxford, Ohio

Pennsylvania Academy (USA Artists Collection)

Smithsonian Institution, Washington, D.C.

University of Charleston, Charleston, West Virginia

West Virginia State Museum, Charleston, West Virginia

This chronology is based primarily on original research by Robert Bridges and Kristina Olson; the Grace Martin Taylor papers on loan from Lucie Mellert at the Art Museum of West Virginia University; the biography compiled by The Art Store, Charleston, West Virginia; Blanche Lazzell papers in the Archives of American Art, Smithsonian Institution; additional research by Stephen Borkowski, Charlene Lattea, Marianne Coalter Peyton, and Amy Metz Swan.

BIBLIOGRAPHY

Acton, David. *A Spectrum of Innovation: Color in American Printmaking 1890-1960*. Worcester, MA and New York/London: Worcester Art Museum and W. W. Norton & Company, 1990.

Bridges, Robert, Kristina Olson and Janet Snyder, eds. *Blanche Lazzell: The Life and Work of an American Modernist*. Morgantown, WV: West Virginia University Press, 2004.

Brown, Brice. *Grace Martin Taylor (1903–1995) An American Modernist, A Retrospective Exhibit*. New York: The Orange Chicken Press, 2001.

Coppel, Stephen and Jerzy Kierkuc-Bielinski. *The American Scene: Prints From Hopper to Pollock*. London: British Museum, 2008.

Cuthbert, John A. *Early Art and Artists in West Virginia*. Morgantown, WV: West Virginia University Press, 2000.

Cuthbert, John A. *West Virginia Vistas and Visionaries: Recent Accessions to the West Virginia University Art Collection*. Morgantown, WV: West Virginia University Libraries, 1995.

Cuthbert, John A. and Gale Simplicio. *Grace Martin Taylor 1903-1995*. Morgantown, WV: West Virginia University Libraries, 1996.

Davidson, Morris. *Painting with Purpose*, New York: Prentice-Hall, 1964.

Flint, Janet Altaic. *Provincetown Printers: A Woodcut Tradition*. Washington, D.C.: Smithsonian Institution Press, 1983.

Hudkins, John F. *Grace Martin Taylor*. Charleston, WV: West Virginia Department of Culture and History, 1981.

Shapiro, Barbara Stern. *From Paris to Provincetown: Blanche Lazzell and the Color Woodcut*. Boston: Museum of Fine Arts Publications, 2002.

We would like to thank Lucie Mellert for the various donations of Grace Martin Taylor art throughout the years. It is through her generosity that this exhibition can take place. Lucie has tirelessly promoted her mother's art for many years. Her mother expressed this gratitude for the support she had provided to the artist.

"In the life of every dedicated artist there is usually one person to whom he is greatly indebted. In my case, the member of my family who tolerated all the trials and tribulations and hardships of the artist was my daughter Lucie Ann Mellert. She studied music at Mason College of Fine Arts, and she understands the feeling and emotions that an artist has. She shared with me, and never complained, and was always present if I needed her."
– Grace Martin Taylor (1981)